D1496080

IMAGES
of America

LINCOLN PARK

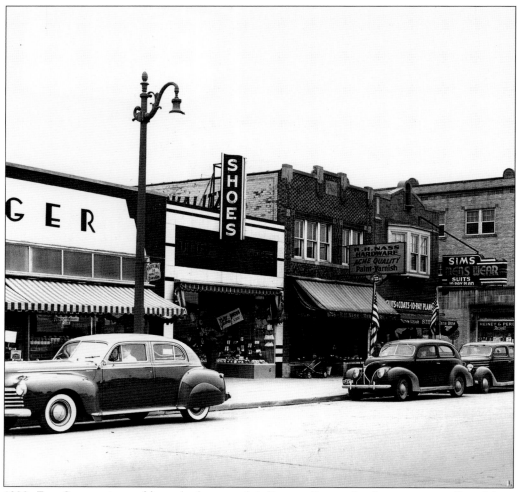

1930s Fort Street, pictured here, looks toward Arlington Street. At this corner was Sims Mens Wear and the Toleikis Building. The Toleikis Building had a Rexall drugstore on the first floor with apartments above. Along this first block of Fort Street was Kroger's, a shoe store, and R. H. Nass Hardware. Fort Street was the prosperous business district for Lincoln Park. Here people could buy their groceries, clothing, or hardware on a single shopping trip. A flag for a patriotic holiday is seen here in front of the R. H. Nass Hardware. Building styles range from brick to sleek art deco building materials.

IMAGES
of America

LINCOLN PARK

Lincoln Park Preservation Alliance

Copyright © 2005 by Lincoln Park Preservation Alliance
ISBN 0-7385-3970-8

Published by Arcadia Publishing
Charleston SC, Chicago IL, Portsmouth NH, San Francisco CA

Printed in Great Britain

Library of Congress Catalog Card Number: 2005931539

For all general information contact Arcadia Publishing at:
Telephone 843-853-2070
Fax 843-853-0044
E-mail sales@arcadiapublishing.com
For customer service and orders:
Toll-Free 1-888-313-2665

Visit us on the internet at http://www.arcadiapublishing.com

We would like to dedicate this book to the citizens of Lincoln Park. We hope you enjoy this book as much as we enjoyed researching our city.

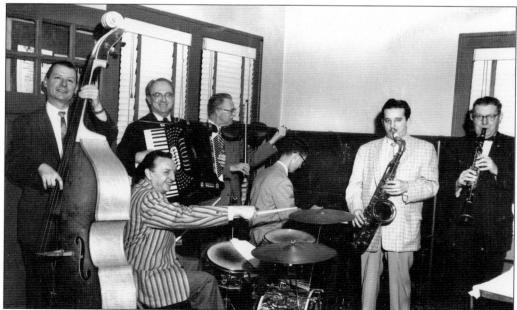

Lincoln Park Exchange Club members play for a club function at the bungalow. Pictured from left to right are Joseph Bodnar, Charles Nixon, Archie Cairns, Morrie Sager, John Doyle, Walter Godfrey, and Edwin Jones. At this function, they entertained senior members of the Lincoln Park High School band.

CONTENTS

Acknowledgments 6

Introduction 7

1. Conspiracy of Pontiac and Council Point 9

2. French, German, and English Settlers 13

3. Quandt's Corners 31

4. From Ecorse Township to the Village of Lincoln Park 37

5. Five Dollars a Day 45

6. Preston Tucker, Local Entrepreneur 55

7. A 20th-Century Melting Pot 61

8. Public Schools 71

9. Business and Municipal Growth 85

10. Churches and Organizations. 119

Index 128

ACKNOWLEDGMENTS

Lincoln Park Preservation Alliance would like to thank the Lincoln Park Historical Commission and Lincoln Park Historical Society in allowing us the use of the Lincoln Park Historical Museum photograph collection for this book. Special thanks to Muriel Lobb, who devoted many hours in addition to her normal hours to open the museum for our scans and research days. Thanks to the Downriver Genealogical Society for the use of their library for research and maps.

Thanks to our tireless volunteers Valerie Brady, Brian Clancy, Debbie Van Cleave, Don Van Cleave, Kay Dudley, Gordon Gilbert, Jim Fox, Amanda Rowe, and Fred Wilson for giving up many evenings and weekends for scans, research, and writing captions. And thanks to a very patient Sarah Rowe, who tagged along with her mom to our photograph scans and research days.

Thanks to Mary Cibor, the Clemente family, the Chiarelli family, Mary Meyer, Lea Moriatis, John Solosy, the Zelenak family, Zeferino Solis, Lincoln Park fire chief Gil Solis, Lincoln Park police chief Thomas E. Karnes, retired Lincoln Park police chief Robert Duncan Sr., and Mayor Steven M. Brown for providing historical information. Thanks to Lincoln Park Rotary Club, Lincoln Park Chamber of Commerce, as well as Jay Follis, Tucker Historical Collection and Library, for providing photographs. Thanks to Robin Lyson, Debbie Van Cleave, and Fred Wilson for providing CDs. Thanks to our scanners Debbie Van Cleave and Fred Wilson.

Leslie Lynch-Wilson, president
Lincoln Park Preservation Alliance

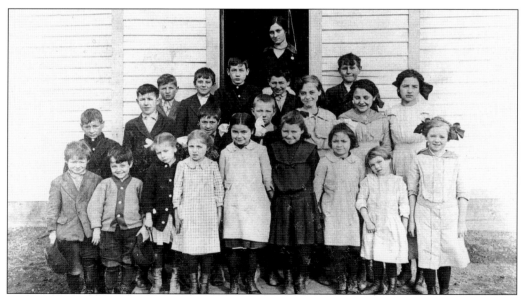

Members of the Goodell School in 1911 include teacher Stella Powers (top center), Walter Zirkaloso, Emery Aben, Albert Montie, Cleophus Goodell, Fred Aben, Frank Champaigne, Fred Showers, Hazel Moat, Elsie Bondie, Alma LeBlanc, Leila Bodary, Vina Montie, Viola Goodell, Mable Montie, and Oneda Bodary.

INTRODUCTION

The purpose in writing this book was to highlight the Lincoln Park Historical Museum. Through the use of the museum photographs, the authors hope to highlight the people, schools, businesses, organizations, and churches that make up Lincoln Park. It is not intended to be a complete history, and there will be other books to continue our story.

The area's earliest residents were the Potawatomi Indians. Chief Pontiac, a Potawatomi warrior, called a council of more than 400 Ottawa, Huron, and Potawatomi chiefs and warriors along the banks of the Ecorse River at the confluence of the north and south branches. On May 7, 1763, Pontiac led his warriors to Fort Detroit to overthrow the British, but he was expected. Pontiac, knowing that his men would be overturned, turned back to the Ottawa village. The warriors later returned to Fort Detroit for a five-month siege. But the endless fighting seemed pointless to the warriors. The French, who were fighting with Pontiac, switched allegiance back to the British and conceded. The Native American tribes made peace and headed home. This series of events is known as the Conspiracy of Pontiac.

At the time of the signing of the Declaration of Independence in July 1776, Pierre St. Cosme, a Frenchman, acquired a huge tract of land from the Potawatomi Indians. This land, granted to St. Cosme and his two sons, included most of present-day Ecorse, Lincoln Park, Allen Park, and part of Wyandotte. The land fronted the Detroit River, extending past the Ecorse River. The northern boundary became known as the St. Cosme Line, now Southfield Road, and the southern boundary is present-day Goddard Road.

Founded in 1827 as Ecorse Township, the name "Ecorse" came from "River Aux Ecorce," derived from the early French settlers who referred to the area as "the River of the Barks." This was because Native Americans gathered by a small stream, which is now the Ecorse River, to strip bark for their canoes. By the early 19th century, homes were built in what was to become Lincoln Park. The first settlement was near Goddard Road. The Monties, Bondies, Laffertys, and Drouillards were early French settlers in Lincoln Park. The area was mostly forest with occasional farms. By 1852, the Goodells, the first English-speaking family, had settled in Ecorse Township, purchasing 120 acres from the Native Americans.

Just after the Civil War, the forest gave way to agriculture. The French families moved westward. Along with them came Germans who had recently migrated to the United States—Keppens, Quandts, Dashers, Schonscheks, and others. Ecorse Township became thriving farmland after the Civil War. A business district soon developed at Fort Street and St. Cosme Line. Seventy years before, Noah LeBlanc had a grocery store at this corner, and then Herman C. Quandt opened a grocery store around 1899. The area soon became known as Quandt's Corners.

In 1911, the first land development in Lincoln Park was established by the Farnham brothers. The Farnhams owned the Suburban Motor Car Company on Mill Street, on the east side of the river. They invested in property that ran from Southfield Road past Lincoln Street. The Farnham family admired Abraham Lincoln and named their developments "Lincoln Park Subdivision Numbers 1 and 2" and named Lincoln Boulevard after him as well.

Henry Ford's "$5-a-day" plan started the development of Lincoln Park. With employment within three miles, the workers began looking for home sites close to their work. A real-estate boom followed. Sales offices sprang up on corners and in tents and tar paper shacks.

In 1921, a desire for improvements and a village form of government led residents to form the Lincoln Park Approvement Association. They petitioned the Ecorse Township board

of supervisors for authority to vote on incorporating the area bounded by the Ecorse River, Gohl Road, the Pennsylvania Railroad, and Pepper Road (now Outer Drive). At a March 1921 election, the proposition was passed by a vote of 208 to 72. A charter commission was elected, and the first charter was drawn up and approved by the governor of Michigan. It was submitted to the people on June 28, 1921, and passed with the same vote of 208 to 72. This area is now the village of Lincoln Park. Mark Goodell became the first village president. Goodell also admired Abraham Lincoln. He suggested the name Lincoln Park for the town.

Less than six months after becoming a village, the street names were changed. Huron, named after the Great Lake, became Lafayette. Erie changed to Fort Park, Ontario to Howard, and St. Clair to Abbott. Other forgotten streets included Bonzano, now Montie; Philladelphia, now Russell; Dearwell, now O'Connor; Stratton, now Cicotte; Marie and Sunflower, now London; Sheridan Park Drive, now Liberty; Kensington, now Elliott; Riverview, now Applewood; and McKenney, now Ferris.

In June 1922, Lincoln Park had a population of 300, but by January 1923, the growing town had a population of about 6,000 people. In 1925, this small village became the city of Lincoln Park. William Raupp was the first mayor, and Lincoln Park was touted as the "City of Tomorrow" by real-estate promoters during the Detroit industrial boom of the 1920s.

In the 80 years since its incorporation as a city, Lincoln Park has become a vibrant residential community with a plenitude of parks, shops, and schools.

One

CONSPIRACY OF PONTIAC AND COUNCIL POINT

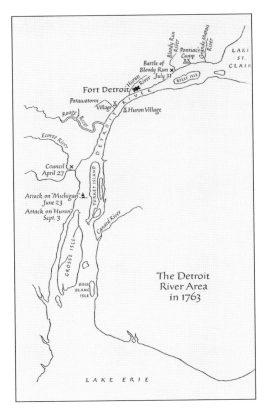

The Downriver area was once the hunting grounds to the Potawatomi Indians. Frenchman Antoine Laumet de la Mothe Cadillac built Fort Pontchartrain in 1701. The French befriended the Native Americans and used the fort for trade. The French surrendered the fort to the British in 1760 as a result of the French and Indian War, and the British named it Fort Detroit and reinforced the defenses. The British refused to supply the Native Americans with food, tobacco, guns, or powder, which fueled unrest. (Reprinted with permission from R. R. Donnelley and Sons Company.)

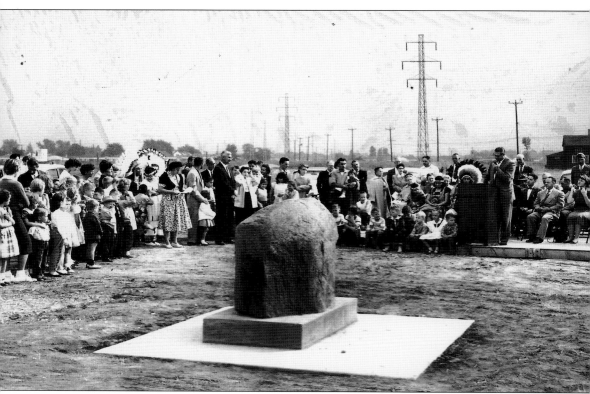

This rock in Council Point Park, on River Drive at the foot of LeBlanc Street, honors the Conspiracy of Pontiac. It was dedicated by the Lincoln Park Historical Society on September 16, 1956. Chief Pontiac, a great orator and strategist, worked to unite the Native Americans against the British. Pontiac called a council of more than 400 Ottawa, Huron, and Potawatomi chiefs and warriors along the banks of the Ecorse River. It is said to have been at the confluence of the north and south branches of the Ecorse River, near the neck of land now known as Council Point or Pontiac Point.

Participating in the Council Point Conspiracy of Pontiac monument dedication are Billy Sebastian and Norbert Hill Jr. (right). During the conspiracy, the warriors returned to Fort Detroit and initiated a five-month siege, which they were not able to prevail. Pontiac's influence was dwindling. The endless siege at Detroit seemed pointless to his warriors, and then the French switched allegiance back to the English. As English troops gained the upper hand and the French conceded to the English, the Native American tribes made their peace and headed home.

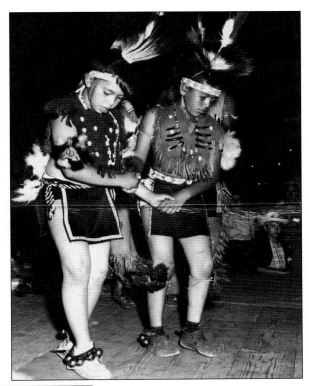

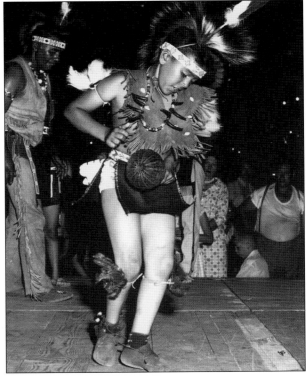

Norbert Hill Jr., a Chippewa Indian, dances at the Council Point dedication. This was not the first celebration honoring Chief Pontiac and his war council. The 200th anniversary was celebrated on May 19, 1963, as part of a Michigan Week observance. The program included dances by 12 American Indians in native costumes. The event was held at the River Drive sewer pumping station adjacent to Pontiac Point, as Council Point was then called, where the Native American council was held in 1763. Lawrence M. Bailey, Lincoln Park city controller, was the master of ceremonies.

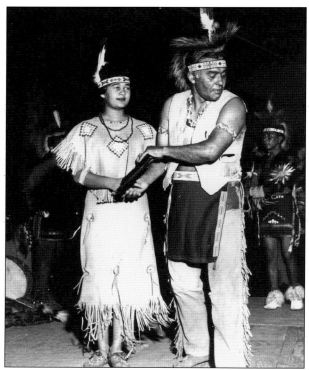

Chief and Mrs. Norbert Hill are shown here dancing at the Council Point dedication. July 1, 1776, the Potawatomi Nation deeded a huge tract of land to Pierre St. Cosme, a Frenchman, living at Detroit. This grant gave St. Cosme and his two sons property that included most of present-day Ecorse, Lincoln Park, Allen Park, and part of Wyandotte. The land fronted the Detroit River on each side of the Ecorse River, extending four miles back. The northern boundary followed what is Southfield Road, and its southern boundary is present-day Goddard Road.

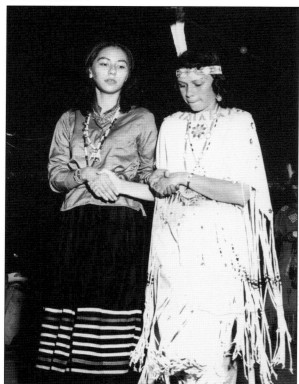

Pictured here are Georgetta Aikens (left), a Chippewa Indian, and Nedda Rathbun of Lincoln Park dancing at Council Point dedication.

Two

FRENCH, GERMAN, AND ENGLISH SETTLERS

The Northwest Ordinance of 1787 allowed for the creation of five states in the Ohio Valley. The territory was eventually divided into the present states of Ohio, Indiana, Illinois, Michigan, and Wisconsin. Wayne County was established in 1796 with its borders extending from Detroit, the county seat, and including most of Michigan, northern Indiana, the eastern edge of Illinois, and a small bit of Wisconsin. Wayne County was named after Maj. Gen. Anthony Wayne (1745–1796), who was also known as "Mad Anthony." Wayne was a Revolutionary War hero from the Battle of Fallen Timbers.

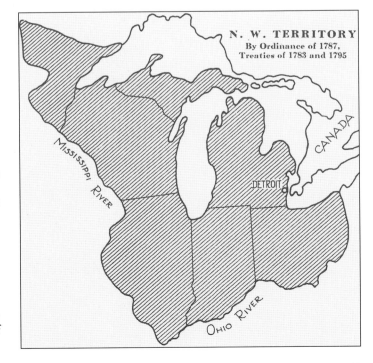

After the death of Pierre St. Cosme in 1787, his wife and sons sold the property to French farmers living in Detroit and Windsor. The early families that settled along the Detroit River near the mouth of the Ecorse River were the Campaus, Salliottes, Labadies, LeBlancs, Goodells, Bondies, Drouillards, and many others. These early settlers purchased "strip farms," only a few hundred yards wide with river frontage, while other strip farms fronted the Rouge River and ended on the northern edge of the St. Cosme property, which became known as St. Cosme Line (then, eventually, State Street and now Southfield Road).

In 1827, Wayne County was divided into townships. Fifty-four square miles of the Downriver area became Ecorse Township. The name "Ecorse" comes from "River Aux Ecorce," which is derived from the early French settlers who referred to the area as "the River of the Barks." This name was due to the fact that Native Americans gathered there by a small stream, which is now the Ecorse River, to strip bark for their canoes.

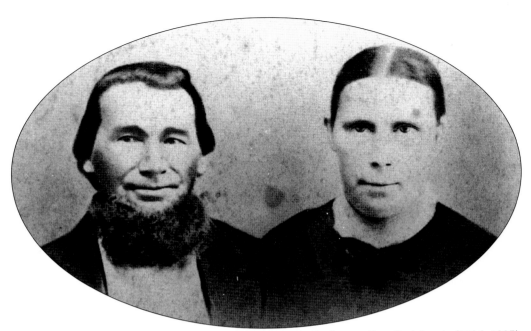

Antoine Montie (1828–1894) is pictured with his wife, Catherine Bondie Montie (1836–1897). Antoine's father, Francis Xavier Montie, was born in France but came from Montreal. By the early 19th century, homes were beginning to be built in what was to become Lincoln Park. The first settlement was near Goddard Road. The Monties were early settlers who settled along Montie Road, while the Bondie and Lafferty families settled along the west bank of the Ecorse Creek (now River Drive). The Drouillards settled in the southern section near Goddard Road. The area was mostly forests with an occasional farm.

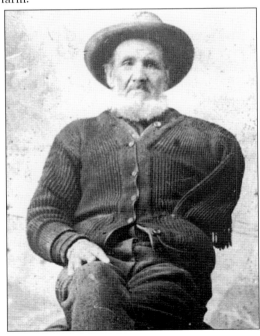

Abraham LeBlanc's (1820–1905) family migrated to Nova Scotia from Normandy, France, in the 17th century, and subsequent generations finally settled in Ecorse in 1801. Abraham, pictured here, was the son of Peter (or Pierre) LeBlanc Jr. and Teresa (or Thorise) Bourassa. He married Phyllis Perry about 1850, had 11 children, and built a home in Ecorse near Mill Street. Abraham LeBlanc served on the first Ecorse Township school board and was a township highway commissioner. He lost an arm in 1887 while working at a cider mill. He gave each of his six sons a farm in the Downriver area.

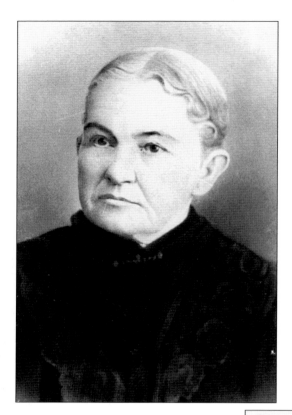

Phyllis Perry LeBlanc (1829–1920) was the daughter of Peter Perry and Louisa Bariau. Some records list the French spelling of Perry as "Pare," as well as her first name as Felicity or Philice. She and Abraham LeBlanc were married in 1852 at St. Francis Xavier Church in Ecorse.

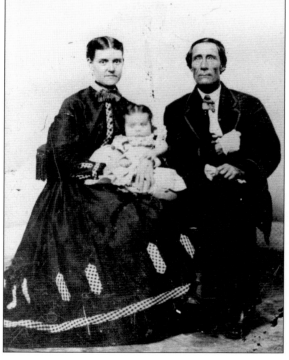

Thomas LeBlanc (1815–1887), pictured here with his second wife, Adeline McQuillan LeBlanc, was the son of Peter Francis LeBlanc and Teresa Bourassa. Their children were Lillie and Thomas. Thomas was the brother of Abraham LeBlanc.

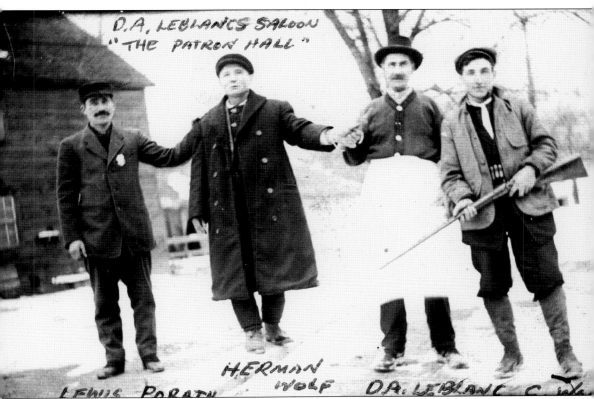

D. A. LeBlanc's Saloon, "The Patron Hall," is pictured here with, from left to right, Lewis Porath, Herman Wolf, D. A. LeBlanc, and C. Wolf. This building, built in 1890, sat on the northeast corner of Fort Street and St. Cosme Line (later State Street and now Southfield Road). The lumber used to build this building came from local trees that were hauled to the Raupp saw mill on the Detroit River at Ecorse Creek. The building was rented to Herman Quandt and Clem Bourassa, who each had a saloon there. The building became a speakeasy after its move to Southfield Road, across from city hall, when Fort Street was widened. The speakeasy catered to Pennsylvania Railroad construction workers known as "gandy dancers." The building became a furniture store after the end of Prohibition and the bootlegging business. Eventually the building was razed.

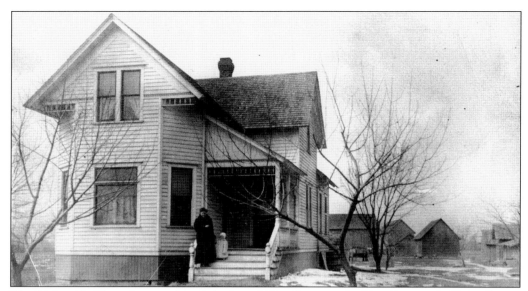

The Richard LeBlanc farm used to sit in the middle of present-day Fort Street at LeBlanc Street. The original house burned down in the early 1920s. There was no fire department, and Ecorse's firefighters were summoned. The fire engine ran out of gas at the Ecorse Creek bridge, and when it finally did arrive at the LeBlanc farm, the fire hydrant was frozen. A new home was built to replace it. The home was moved on the west side of Fort Street when Fort Street was turned into a divided highway.

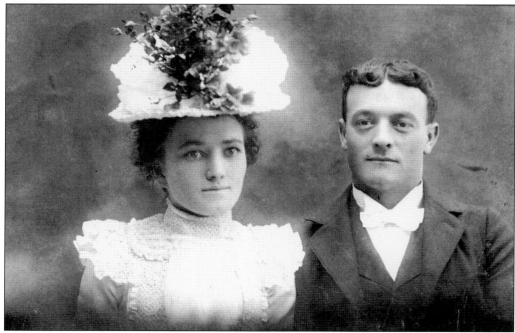

George Bondie is pictured here with his wife, Ida Foley Bondie. George Bondie's parents were Joseph Bondie and Elizabeth Labadie. George and his brother Eli operated a grocery store in Delray called E. R. Bondie Grocier.

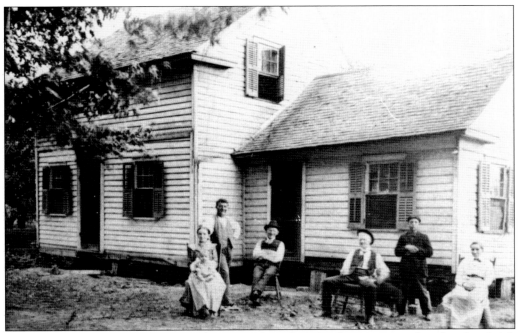

The George Bondie home, pictured here, stood until 1918, when it was replaced with a brick house. The original family farm was in the vicinity of Fort and Champaign Streets. All the Bondie children were born and raised in this house.

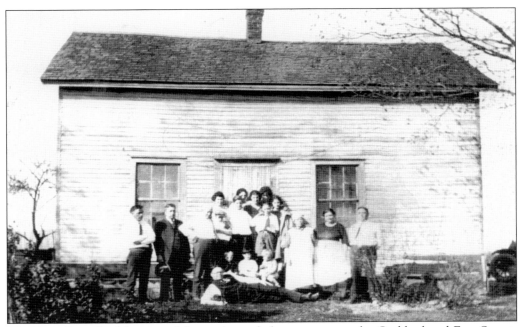

The Peter Drouillard home and farm, pictured above, was near the Goddard and Fort Streets area. Peter Drouillard is seen second from left. Anna Drouillard is seen second from the right, Iva Drouillard is fifth from the left, and Elenore Drouillard is fourth from the left.

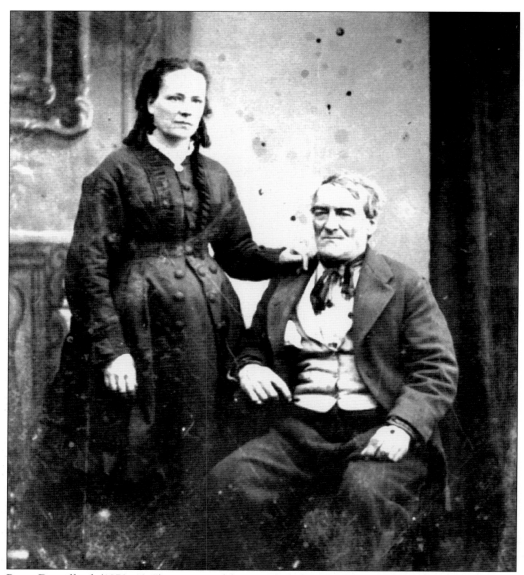

Peter Drouillard (1873–1947) is pictured here with his wife, Anna LeBlanc Drouillard. Peter Drouillard's family tree can be traced back to Jean Drouillard and Jane Chevreau Drouillard, residents of Marenne, France, in the mid-17th century. Jean and Jane Drouillard's son Simon migrated to Canada and settled in Quebec. Later generations migrated to Montreal and Sandwich, a Windsor suburb, and eventually Detroit. It was Jean Baptiste Drouillard, born in Detroit in 1805, who had purchased land in 1808 from the St. Cosme family. The land was between the Detroit River and Ecorse Creek, in what eventually became Ecorse Township and, later, Lincoln Park. Jean Baptiste's son Toussaint Drouillard purchased a "strip farm" on the Wyandotte and Lincoln Park border near Goddard and Fort Streets. Toussaint Drouillard was the grandfather of Peter Drouillard. Peter Drouillard was a farmer and lived his entire life on the family farm at 1130 Goddard Street. The early members of the Drouillard family worshiped at St. Francis Xavier Catholic Church in Ecorse, where they traveled every week by horse and buggy from their various farms in the area.

Johan Lindeman, pictured here with his wife Catherine (below), bought land in Ecorse Township in 1858. They came here from Mecklinburg, Germany. Their daughter Anna married August J. Keppen.

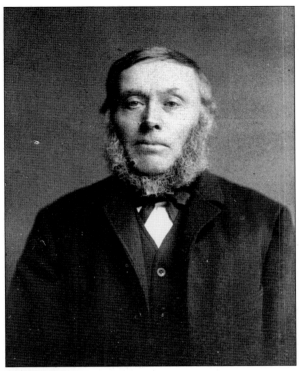

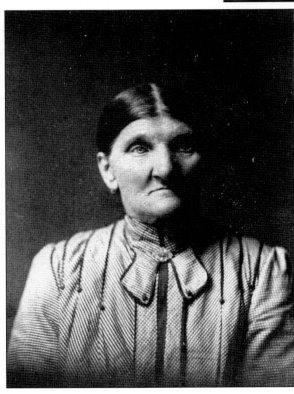

Catherine Lindeman is pictured here.

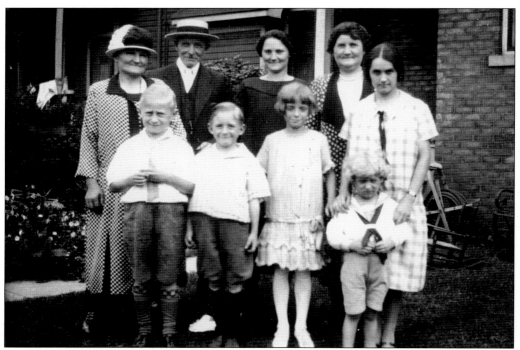

From left to right are the following: (first row) Chester Keppen, Richard Gerisch, Dorothea Gerisch, Robert Keppen, and Ella Keppen; (second row) Anna Keppen, August Keppen, Mamie Keppen Gerisch, and Minnie Lindeman Gerisch.

The Lindeman, Keppen, and Gerisch families are pictured in 1919 in Lincoln Park.

Louis and Mamie Keppen were the children of August Keppen and Anna Lindeman Keppen. Mamie (1889–1968), whose real name was Marie, married Richard B. Gerisch in 1907. Louis (1891–1956) married Anna Louisa Wischer. Another son, Frederic J. (1912–1984), married Helen Eberts and was the Lincoln Park city attorney.

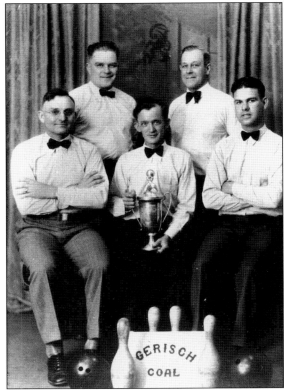

Pictured here are Louis Keppen, James Green, and Robert Taylor. Louis J. Keppen was a coal dealer with Gerisch Coal of Detroit and Lincoln Park's first treasurer when the village was incorporated in 1921. James Green was a musician and organist. Robert Taylor had a barbershop on Fort and O'Connor Streets by the old bank.

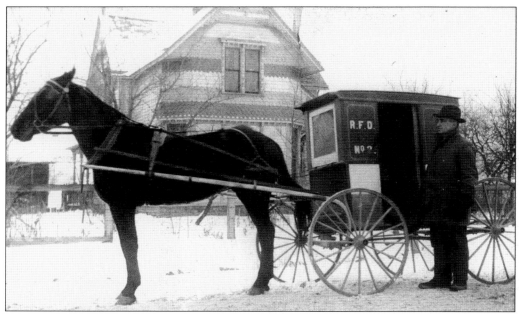

Keppen Farm, pictured here, was at Fort Street and Southfield Road. The Keppen home is a Queen Anne–style Victorian.

The Keppen home is pictured here at 1317 Arlington between Fort Street and Fort Park Boulevard. In the mid-1920s, the home was moved to 1317 Arlington, as Fort Street was cut through and the Keppen property was subdivided. Eventually the Arlington Street land was needed for municipal parking, and the house was moved to Garfield Street. It is still located at 1314 Garfield.

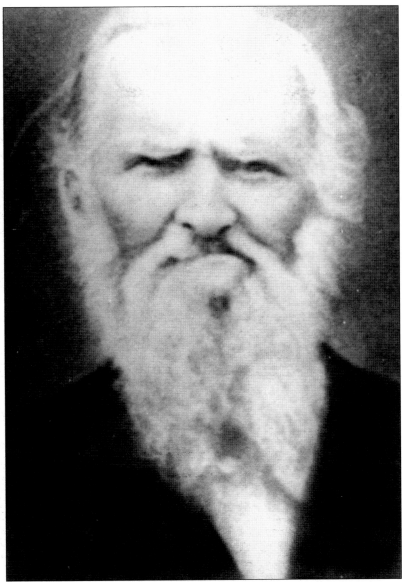

Cleophus T. Goodell (1830–1915) was the grandson of Elijah Goodell (born 1758), who had fought in the Revolutionary War. Goodell's ancestors left France for religious freedom in the 16th century and fled to England. Elijah Goodell migrated to Canada in the 1790s from the Mohawk Valley in New York to avoid an oath of allegiance to the British crown. In the late 1790s, Goodell farmed and operated a lime kiln on Grosse Ile. Elijah Goodell's log cabin in Ecorse served as the social, community, and religious meeting place. The Goodells had a large family that mostly settled in Ecorse. Elijah's grandson, Cleophus, settled in Ecorse Township in about 1852, purchasing 120 acres from the Native Americans and building a four-room farmhouse. As the family grew, so did the farmhouse. A music room, sunroom, additional parlor, and first-floor bathroom were added. In addition, the second floor was expanded to four bedrooms, and the third floor consisted of a large room. A large front porch was added to the front and east sides of the house. Cleophus Goodell helped found Goodell School in about 1869.

Cleophus Goodell married Philomene Riopelle, who came from another Downriver pioneer family. They raised five children—Mary Oceana Quandt, Thomas Goodell, James Ira Goodell, Mark Goodell, and Anne Philomene Theeck—at 2136 Fort Park Boulevard, which was built by Cleophus. The Goodell children were deeded nine-acre plots by their parents. These plots covered most of the land between Fort Park Boulevard and Ferris Street, Ferris and Austin Streets, Chandler and McKinley Streets, and McKinley Street and Fort Park. There were two other nine-acre plots that extended beyond the original farmhouse across Dix Avenue to the present city limits. One of the Goodell family homes is pictured here.

Mark Goodell, the first village president, was born on September 8, 1884, in the original Goodell farmhouse. After graduating from high school, he attended the University of Detroit to study medicine. He was also a member of the football team. Mark later decided against a career in medicine to pursue real-estate development and local politics. Goodell was elected first village president in 1921. He was instrumental in the formation of the City of Lincoln Park in 1925 and served as the second mayor. Goodell's influence is evident in some of the city street names: Cleophus, Philomene, Markese, Riopelle, Oceana, Quandt, Jonas, and possibly Mark Street.

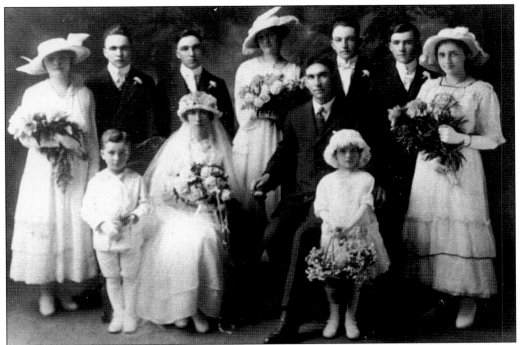

This image shows the June 21, 1916, wedding of Lottie Bachelor and Mark Goodell. Mark Goodell met Lottie Bachelor, of Dearborn, in 1915 when she came to the Goodell farm to inquire about a teaching job at the Goodell School. Mark Goodell was president of the school board at the time. He hired her on the spot. After their wedding, the couple lived at 2136 Fort Park in the house built by Cleophus Goodell. Mark and Lottie Goodell had seven children: Gerald (who died at age seven), Philomene, Jocelyn, Geralee, Markese, Mark, and William.

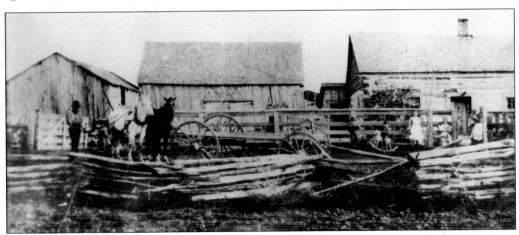

Pictured here at the Raupp farm are, from left to right, Matthias, William, Matthias Jr., Ann, Rose, and Minnie Schonfield Raupp. German-born Matthias Raupp came to Lincoln Park in 1878. Land was cleared for farming and a log house at the corner of Dix Avenue and Pepper Road. Matthias and his brother Gustave had a sawmill, Raupp Lumber and Coal Company, on the Detroit River in Ecorse. William Raupp was the second village president, first mayor of the city, city councilman, and was also on the Ecorse Township and Lincoln Park school boards.

Henry and Jennie Rumsley lived at 1367 Wilson Avenue. The Rumsleys came from England via Canada.

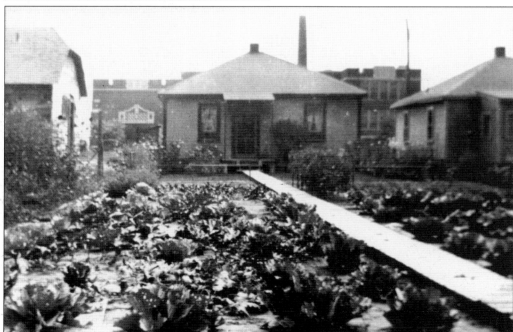

This house belonged to Henry and Jennie Rumsley. This is one of the "garage houses" that are so common to Lincoln Park. Notice the "victory garden" in the front yard.

Here is an old baseburner stove at the
Rumsley home.

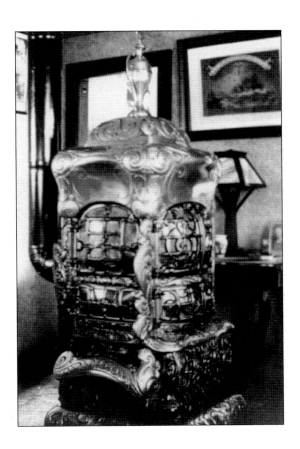

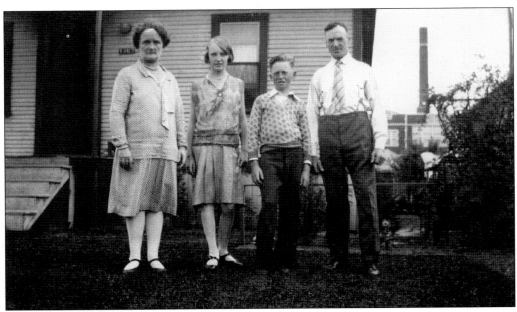

From left to right in this picture are Jennie, Dorothy, Ernie, and Henry Rumsley.

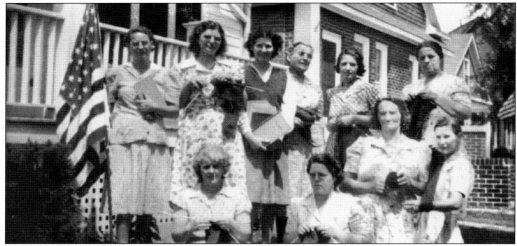

Pictured here is the 1940s Austin Street Knitting Club. From left to right are the following: (first row) Mrs. Coral, Mary Stepeh, Rosie Glogowski, and Elizabeth Hegedus; (second row) Mary Rozsnyai, Mary Perona, Virginia Marshall, Josephine Hansen, Elizabeth McCluskey, and Bessie Green.

This is James Green (1879–1968) with his daughters Shirley (age one) and Virginia (age six) in approximately 1922. Green was born in London, England, and served in the Royal Army for several years before moving to the United States. He studied music at Cambridge and other universities. He taught music in New York State and then came to Detroit. In 1916, he built a home at 1226 Austin Street in the Ecorse Township, upon the recommendation of a friend. Green served on the village council until Lincoln Park was incorporated as a city in 1925. He devoted most of his life to music.

Three

QUANDT'S CORNERS

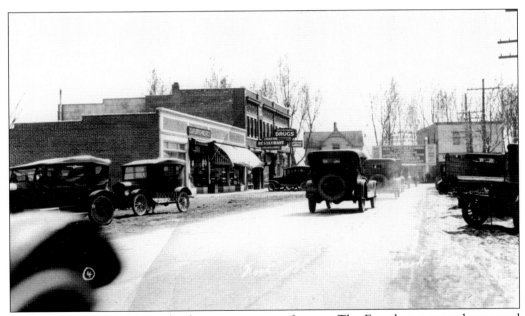

Just prior to the Civil War, the forest gave way to farmers. The Frenchmen moved westward from the Detroit River farms, and along with them came the Germans who had recently migrated to the United States—Keppens, Quandts, Dashers, Schonscheks, and others. The area became thriving farmland after the Civil War. Ecorse was "town" for the farmers, but a business district developed at Fort Street and St. Cosme Line (later State Street and then Southfield Road.) Noah LeBlanc had a grocery store at this same intersection 70 years earlier, and then Herman C. Quandt opened a grocery store about 1899.

Herman Quandt's West Side Inn, which stood at the intersection of Fort Street and St. Cosme Line, was a Lincoln Park landmark for many years. Built in 1899, it was the center of the community's social and civic life during the first quarter of the 20th century. In 1908, Quandt built a new building that became the community center. Lincoln Park became a village in 1921. The upstairs of the tavern served as the meeting location of the village and city council.

Herman C. Quandt was born in 1871 in Taylor Township and grew up on his parents' farm at the corner of Allen and old Pepper Roads (Outer Drive). Quandt was one of the area's first businessmen. In 1888, Quandt married Mary O. Goodell. Mary was the daughter of Cleophus and Philomene Goodell, who are the namesakes of several streets and schools. Mary Quandt was born on her parents' Ecorse Township farm. Herman and Mary Quandt had four kids, Frances Quandt James, Edna Quandt Wilber, Ethel Quandt Barko, and Herbert.

Mary O. Quandt's mother, Philomene, was a Riopelle, another Downriver pioneer family. Mary, seen here, was married for 48 years to Herman Quandt. She was one of the few who advocated the incorporation of Lincoln Park as a village. She was also active in the campaign to establish the village of Lincoln Park in 1921 and later advocated the incorporation of the city in 1925. Mary belonged to several neighborhood groups and was active in St. Henry's Church.

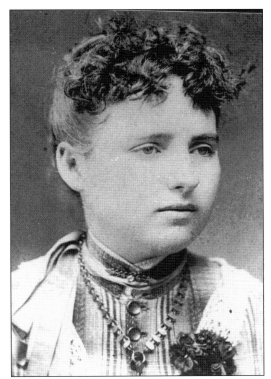

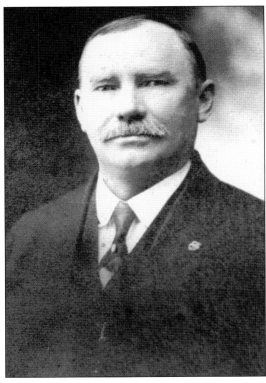

Herman C. Quandt, pictured here, was an active member of the community and served as a highway commissioner for many years. He loved hunting, fishing, and trips up north for deer season.

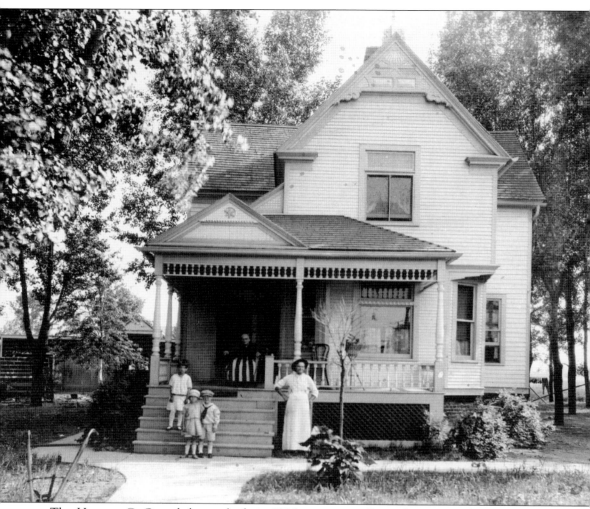

The Herman C. Quandt home, built in 1906, was originally at the corner of St. Cosme Line and Fort Street. It was moved to Fort Park and Philomene Street in 1925 when Fort Street was straightened and cut through. Fort Street literally ran up to the Quandt's front door and then turned right to the present Fort Park Boulevard. Herman Quandt's home is a Victorian-period, Queen Anne–style home. The Fort Park Boulevard land, to where the home was moved, was the site of the original Goodell farm. This land, nine acres, was left to Mary Quandt from her father Cleophus Goodell. The land consisted of the very center of Lincoln Park, where the library, historical museum, city hall, Fort Park Bowl, and several other buildings and lots now stand. Sitting on the front porch of the home in this image is Philomene Goodell. The children, from left to right, are Noreen Theeck Mullins, Bernice McQuade, and Forrest Hinch. Standing to the right of the steps is "Derby" Herman Smith, a bartender in Quandt's Saloon.

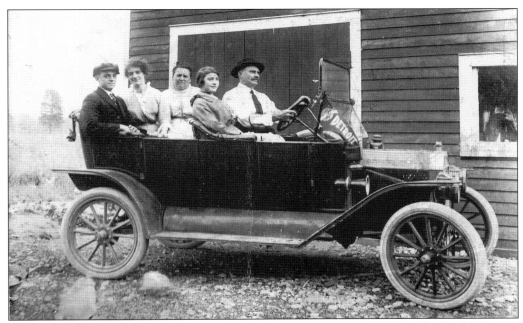

Herman Quandt's 1911 Ford touring car was the area's first automobile. Its high wheels were ideal for driving through the mud roads in the Quandt's Corners area of Ecorse Township. In the front seat are Herman Quandt and Frances Quandt James; in the rear seat are Delbert Wilber, Edna Wilber, and Mary Quandt.

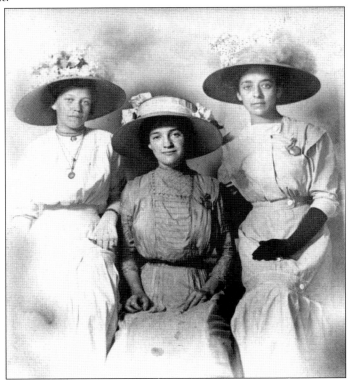

Pictured from left to right in this image are Flora Aben McQuade, Edna Quandt Wilber, and Frances Quandt Hinch James.

This is John Quandt, the father of Herman C. Quandt.

Here is Mary Quandt, the mother of Herman C. Quandt

Four

FROM ECORSE TOWNSHIP TO THE VILLAGE OF LINCOLN PARK

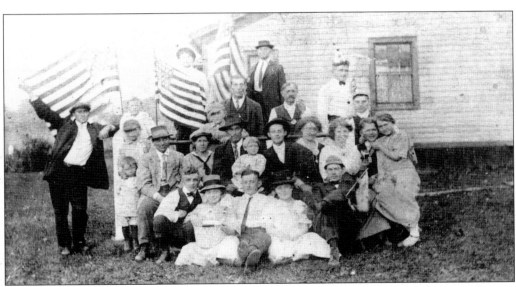

A group of citizens celebrate the Fourth of July, 1902, near Montie and Washington Streets. Fourth of July festivities were very inexpensive at the dawn of the 20th century. The large French families were simple folk who looked to simple things. They were content with making a pail of ice cream and a batch of cookies to eat. The parents would buy a special Fourth of July package of firecrackers and a box of caps for the children's toy gun. Picnics were common, with homemade ice cream, pies, cake, candy, root beer, lemonade, and ginger pop to eat and drink.

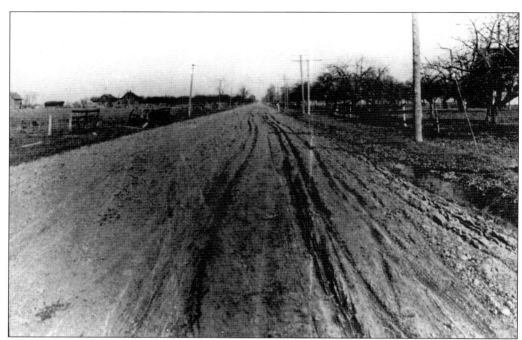

This is a view of Fort Street in 1911. Ecorse Township was a collection of narrow, muddy roads that connected the farms. The roads were merely wagon paths that became impassable after rains.

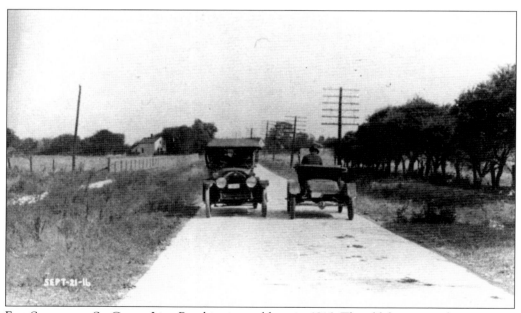

Fort Street near St. Cosme Line Road is pictured here in 1916. The old farms were beginning to be subdivided by this time. The few scattered houses are within a few blocks from the Inter-Urban car line. The population was 600. Fort Street had been paved several years prior, but it was still the only hard-surfaced street in town during this period. St. Cosme Line, now Southfield Road, is still an unpaved road.

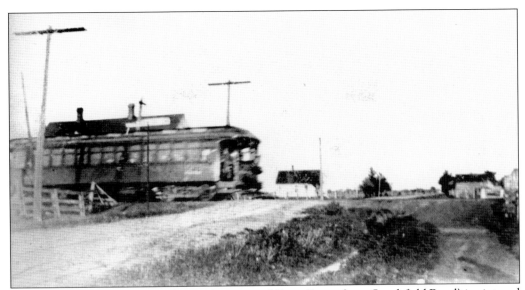

The Inter-Urban Railroad at Electric Avenue and State Street (now Southfield Road) is pictured here. The Inter-Urban was an electric train system that came out of Detroit over the lines of the Detroit, Monroe and Toledo Short Line, running south through Lincoln Park along Electric Avenue. The Inter-Urban, orange-colored cars were larger than streetcars (which only ran in Detroit) and ended at Fort Street and Outer Drive. The Inter-Urban cars ran faster than the Detroit streetcars as well. They provided good, reliable service, leaving State Street for Detroit at 5:37 a.m. and running every 15 minutes until 9:00 a.m. The Inter-Urban ran until 1927.

The family of Michael and Sofia Sabadash moved into what later became Lincoln Park in 1918. Pictured here are Michael and Sofia along with their children, Helen, Mary, Charles, George, and Ann. Michael Sabadash operated a small trucking business that later expanded and grew into a major industrial contracting firm, Sabadash and Sabadash. This business paved many of the early roads in Lincoln Park and the Downriver area, such as Dix Avenue, Southfield Road, and Telegraph Road, to name a few.

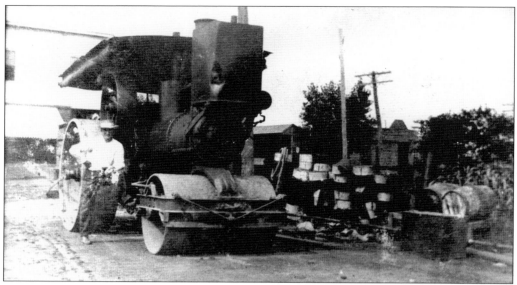

This image shows the 1920s paving of Fort Street. In early road-paving projects, materials such as cinders, available in ample quantities from Wyandotte's chemical plants, were used to pave roads like Fort Street. As technology and surfacing material evolved, heavy-duty machinery would be needed for the task. A local Lincoln Park firm, Sabadash and Sabadash, was instrumental in paving many early roads in the Downriver area. Starting as a small trucking firm, Michael Sabadash would haul the surface materials used in early road projects. Later, as the firm grew, it added the heavy equipment necessary for modern road construction.

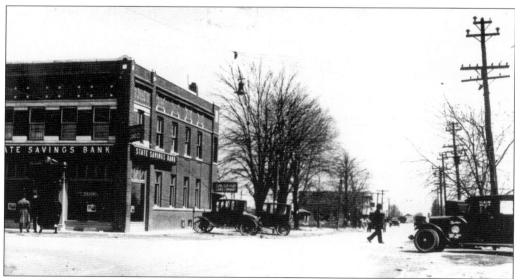

This view looks east on State Street at Fort Street. Such was the view at Fort Street and Southfield Road in 1921. As a portion of Ecorse Township with fewer than 150 residents, Fort and Southfield then was hardly the bustling intersection it would become by the end of the decade. By 1952, this intersection would be known as the crossroads of the Downriver area. Fort Street and Southfield Road was then one of the busiest intersections in Wayne County, handling 70,000 vehicles a day.

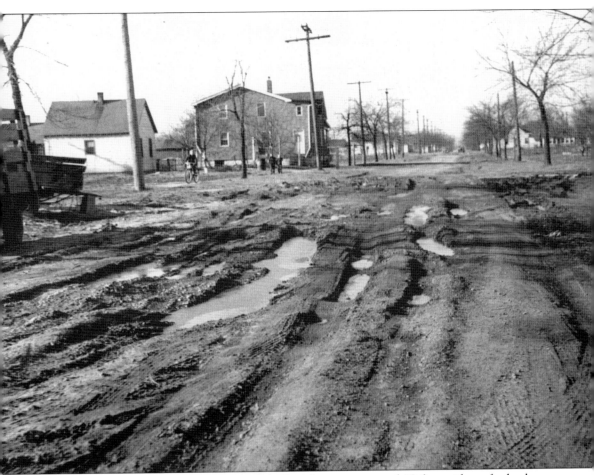

Frank Street is pictured here in 1921. While Fort Street was paved 12 feet wide as far back as 1912, nearly all of the residential streets in Lincoln Park were dirt roads. These roads quickly turned to mud and were often impassable when the rains came. For this former farming community to grow, it needed development. Early visionaries of Lincoln Park were quick to realize that development required infrastructure—and some might argue, it came a little too quick. Anticipating a building boom that would follow World War I, the city installed sewer systems, roads, and sidewalks in undeveloped and uninhabited areas of town. In the process, accumulated debt eventually exceeded $4 million. When that growth failed to materialize as expected, partially a result of the Great Depression, this young community quickly found itself in dire financial straits.

DONATION ONLY
JITNEY
LINCOLN PARK

This sign had to be displayed on private cars used as jitneys. Jitneys, starting in 1921, were used by citizens who did not have cars. They were allowed to run from 5:30 a.m. until 7:00 p.m. They had no set fees and could only accept donations.

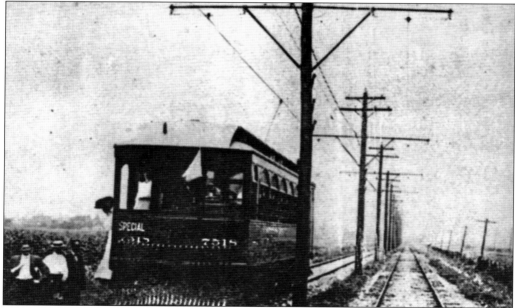

An Inter-Urban is pictured at the pickup place at Southfield Road in 1921. The Inter-Urban was a rail system that connected Detroit with the outlying villages and farming communities around it. Its tracks ran alongside the roads. The Inter-Urban started out in 1890 with the Ypsi-Ann line. By January 1, 1901, the Detroit streetcar lines were consolidated into a single corporation, the Detroit United Railway. The Detroit United Railway set out to acquire all of the Inter-Urban lines operating into Detroit. The Inter-Urban fizzled because of the Depression, better roads, and private automobile ownership. The lack of taxes and regulations on the inner-city buses was another factor.

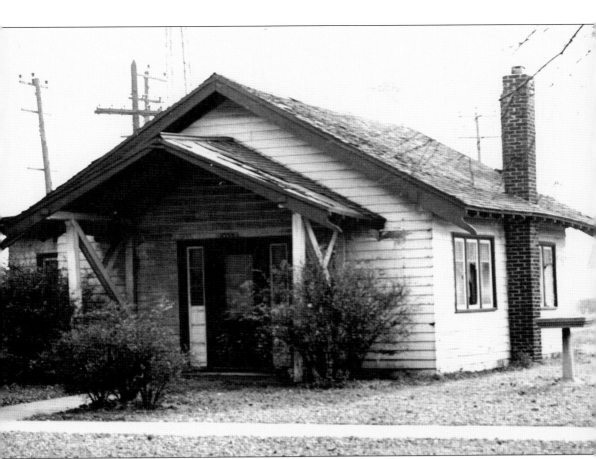

The Lincoln Park council chambers are shown here in 1921. During this year, when Lincoln Park was incorporated as a village, it was used as council chambers at 1035 Lincoln Street, near Electric Street. The building and two lots were a gift from G. W. Zanger, a prominent Detroit resident, who owned a lot of property in the town. In 1924, the chambers were abandoned as a meeting place when the village moved its headquarters to the former Quandt Saloon at Quandt's Corners. During the Depression, the building served as a temporary house for several families. It was also used as a storage shed for the department of public works. The land where the building sat was originally a park for Lincoln Park. There was also a band shell for concerts. In 1953, the building had to be moved from the Lincoln Street location to make room for the enlarging of a city pumping station that sat behind the building. It was moved to the Howard Street and Cicotte area for police department use. The building was eventually torn down to make way for I-75.

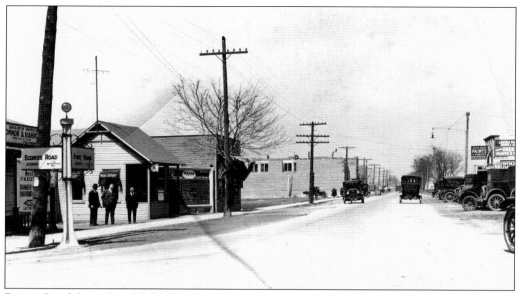

Ecorse Road (now Southfield Road) and Fort Street are pictured here in 1921. Then a part of Ecorse Township with fewer than 150 residents, the village of Lincoln Park would grow to 5,100 in less than two years.

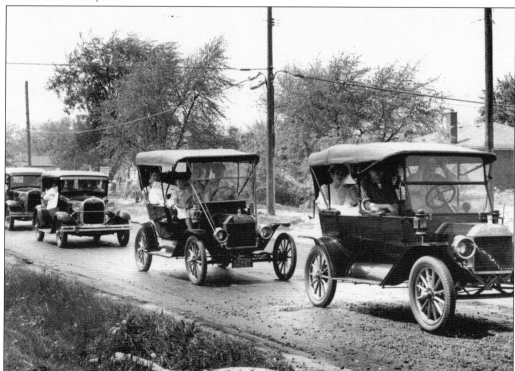

On July 4, 1921, the new village celebrated its first holiday with a full day of festivities. Food, bands, baseball games, and plenty of home-brewed beer were part of the day's events. Later that evening, a fireworks display was provided, courtesy of funds donated by area businesses.

Five

FIVE DOLLARS A DAY

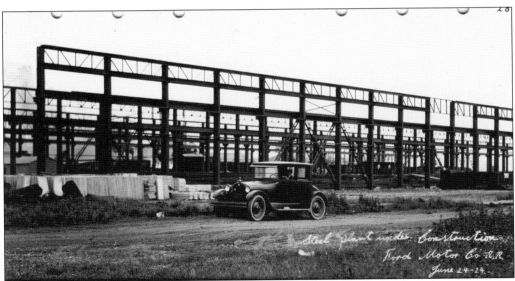

By 1920, Henry Ford had moved production from his Highland Park location to a 2,000-acre site on the Rouge River. As Henry Ford built more than two dozen steel and glass, single-story buildings on the site, the jobs soon followed. Pictured here is the early stage of construction of the steel plant in June 1924 at Ford Motor Company's Rouge complex in nearby Dearborn. With plentiful industrial and factory jobs just minutes away, Lincoln Park would soon fully realize its destiny and become a community of single-family homes, shopping stores, and a professional-services center.

Real estate was big business in Lincoln Park in the 1920s. As workers flocked to the area to seek $5-a-day jobs at the Ford Rouge Plant or the nearby steel mills in Ecorse, Lincoln Park's location proved an excellent area to build a home and raise a family. One could enjoy the tranquility of fine residential streets without the noise and dirt associated with the large industrial plants nearby.

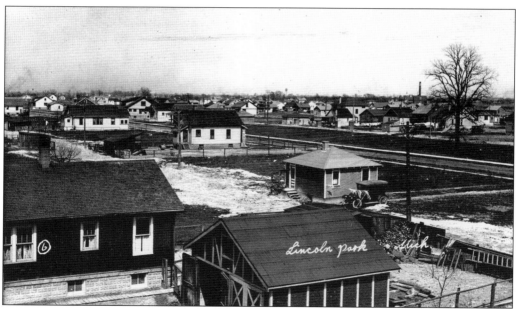

Development began to take shape in the 1920s. While some houses were beginning to appear in this former farming community, ample undeveloped property remained. With a plethora of jobs available in the area, it would not be long before ambitious developers recognized Lincoln Park as a highly desirable area for residential development.

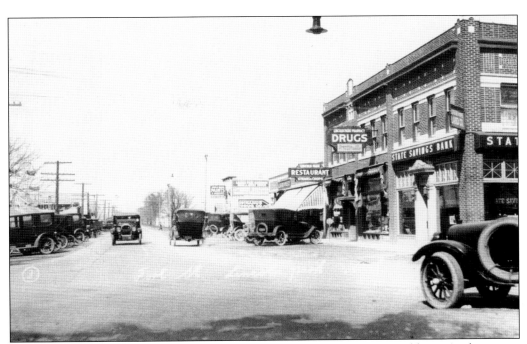

North Fort Street at State Street (later Southfield Road) in 1921 is pictured here. At this point, businesses such as this brick building, which was the State Savings Bank, are beginning to pop up on Fort Street. This photograph depicts how Lincoln Park developed into a nice, small village with a corner bank, a drugstore, a restaurant, and a paint store.

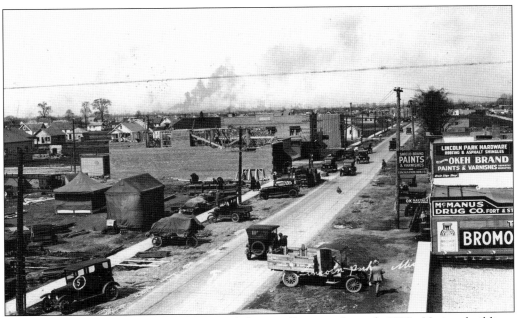

This aerial view shows north Fort Street at Arlington Street in the early 1920s. Various buildings are under construction near already existing businesses. The smoke in the distance is coming from Ford Motor Company's Rouge Plant.

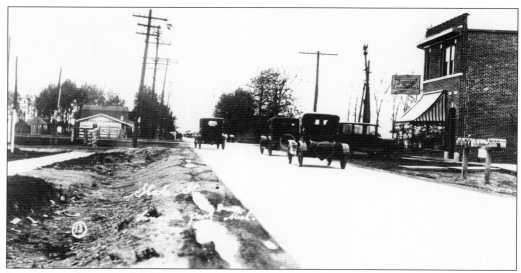

State Street (later Southfield Road) at Electric Avenue is pictured here in the early 1920s. The Inter-Urban tracks are just barely visible in this image. Floyd Harrison's "Harrison Block" is the brick building to the right.

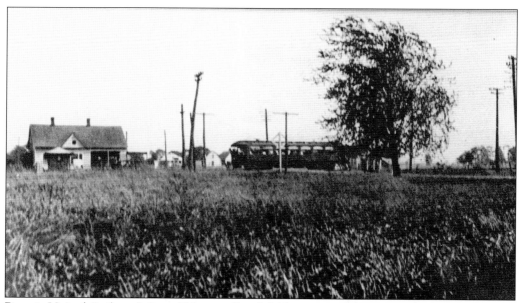

Detroit United Railways's Inter-Urban at Southfield is pictured here in 1921. Before the days of paved roads and superhighways, travel was often slow and arduous. For many, the only dependable transportation available was the Inter-Urban train lines. Whether it was shopping trips to Detroit or Wyandotte, merchants bringing finished goods into town for sale, or pleasure riding excursions to Toledo, the Inter-Urban was the transportation mode of choice. The train line through Lincoln Park ran along what is now Electric Avenue. Once the automobile began to take hold, the electric trains began to disappear. By the late 1920s, they were gone.

Featured in this image is the 1923 Lincoln Park Athletic Club. These unidentified members are shown at Goodell Park, which was then located at Southfield Road and Fort Street. In 1939, this site became the location of the new post office that served Lincoln Park and the Oakwood section of southwest Detroit. Today the building is home to the Lincoln Park Historical Museum and is designated on the National Register of Historic Places.

The trolley turnaround at Fort Street and Outer Drive is pictured here. The term "trolley" and "streetcar" were used interchangeably, but by the early 1890s, people began calling streetcars "trolleys" due to the trolley wheel. The need for expansive land often took factories to the outskirts of town. In the days before automobiles were widely owned, many workers needed reliable transportation to reach the job site and often used public rail systems to get them there. With its location right at the hub of the Downriver industrial complex, Lincoln Park was a short trolley ride to a vast number of employment opportunities available in the area.

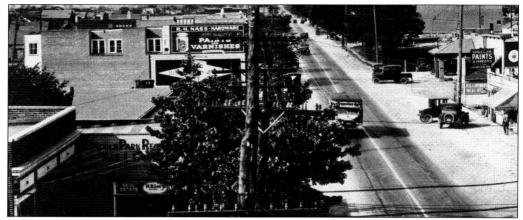

This 1925 view of Fort Street at Southfield Road looks north. Commercial buildings are starting to fill in this major intersection in town. By 1925, the former Quandt's Corners—previously consisting of small businesses owned by early settlers such as Noah LeBlanc and Herman Quandt—was quickly expanding. This was in order to service the flood of people coming to the area for the revolutionary wage of $5 a day offered at the nearby Ford Rouge Plant.

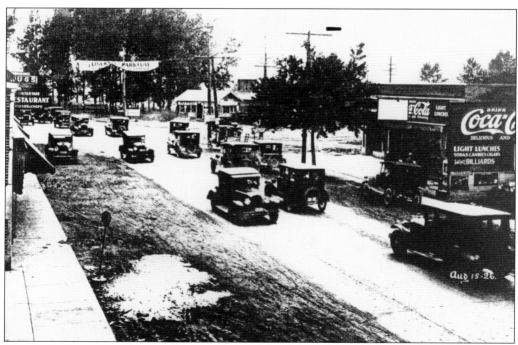

Lincoln Park was on the move in 1926. Fort Street, which just a few years earlier consisted of a saloon, a grocery store, and few other buildings, was now becoming a busy thoroughfare. Lincoln Park experienced explosive growth in the 1920s. From a population of less than 300 in 1922, the city had grown to 8,000 residents by 1924. Crowded streets were replacing the tracts of farms that dominated the area just a few years earlier.

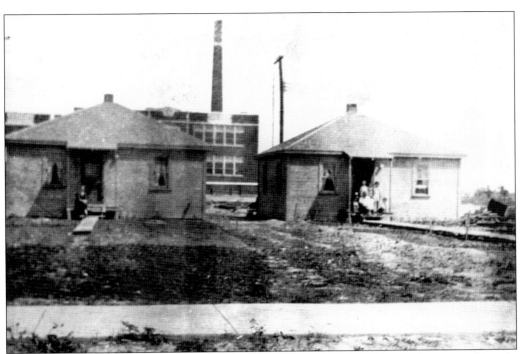

These garage houses, located at Wilson and Cicotte Streets, were common fixtures in Lincoln Park in 1926. Many individuals who purchased lots in new subdivisions built the garage first as temporary housing until the house could be completed some time later. Some decided these temporary structures suited them fine, and the front of the lot was never developed. Many of these early garage homes can still be found in the city today.

Pictured second from the right is George Shanley. Shanley was in the real estate and insurance business in the early days of Lincoln Park. He also served as a commissioner when Lincoln Park became a village in 1921, and he later helped draft the city charter when Lincoln Park became a city in 1925. He also served on the city council some years later.

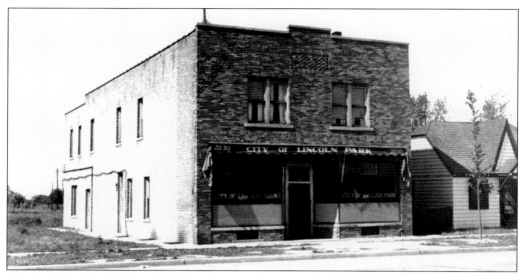

Lincoln Park City Hall at 2030 Fort Street is shown in this image. This building was city hall prior to the current one on Southfield Road. It was built in about 1906 as a tavern for Herman Quandt and was originally located at what is now the center of Fort Street, south of Southfield Road. Later it moved to the northwest corner of Southfield (then St. Cosme Line) and Fort Street when Fort Street was widened. Quandt's building was moved to Southfield Road and later to 2030 Fort Street. The building had been city hall, a Wayne County library branch, and Times Furniture Company.

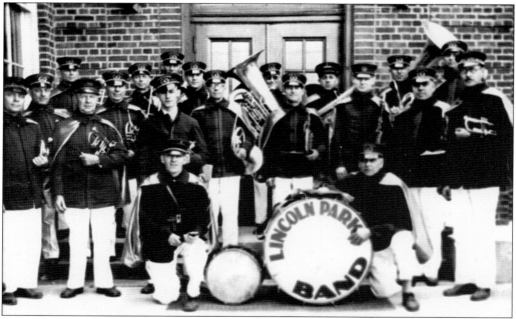

This image depicts Lawrence Bailey and the Lincoln Park Band. Lawrence Bailey (far right, with mustache) was hired as a city controller in 1925. He became involved with Lincoln Park and was a very active part of the town's history. He put together the first Lincoln Park band in 1930 and also started the first historical museum with other Lincoln Park citizens.

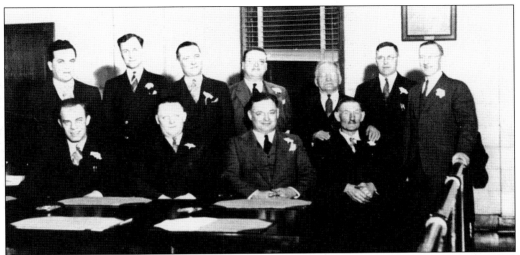

This 1930s photograph shows Lincoln Park City Council chambers. Pictured are, from left to right, the following: (front row) councilmen Russell J. Comer, Russell V. White, George P. Shanley, and William Raupp; (second row) Judge Norman S. James, Mayor Jasper N. Howard, councilman Clarence Hicks, clerk John M. O'Connor, constable Adolphus LaBreck, councilman Winfred L. Crowley, and treasurer Floyd W. Harrison. Jasper Howard was mayor from 1935 to 1937, and William Raupp was mayor from 1925 to 1927 and again from 1929 to 1931.

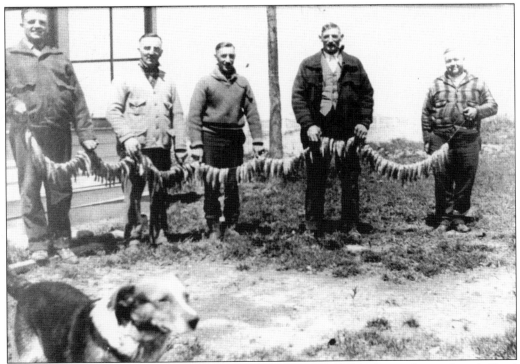

These people, photographed in 1926, are (from left to right) Clyde Johnson (councilman), Floyd Flynn (judge), Floyd Harrison (treasurer), William Raupp (mayor), and Robert Hamilton (school board). Dinnie the dog is seen in the foreground. All are enjoying a day's catch in Saginaw Bay.

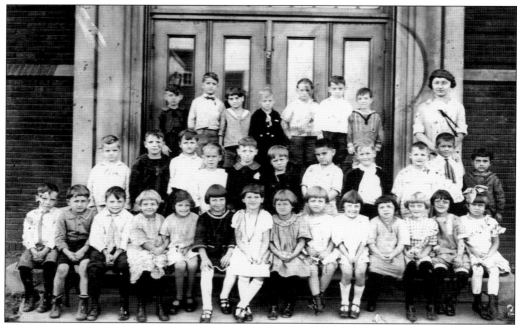

The first grade class at Goodell School is shown here in the late 1920s. The 1920s housing boom brought more students for Lincoln Park. Lincoln Park's incorporation as a city led the way for the Michigan state legislature to allow the Lincoln Park school district to encompass the school boundaries of its schools. Eventually a superintendent of schools was needed, and Leo Huff was given the position in 1928. Another set of problems developed for the school district, since funds were not available for expansion or building improvements. In 1928, a bond issue was passed by the voters to relieve the crowded schools.

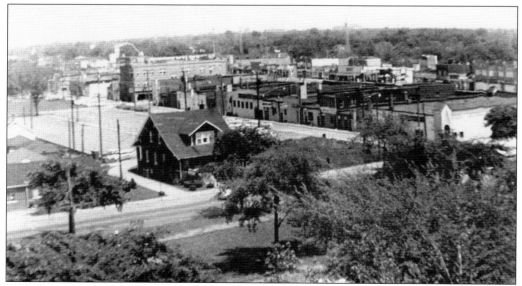

This is a 1930s aerial view of Southfield Road, the Louis Keppen home, and the back of the Fort Street businesses. This land had been the old Keppen farm. The Louis Keppen house would be transformed into Aleks Funeral Home in the mid-1950s.

Six

Preston Tucker, Local Entrepreneur

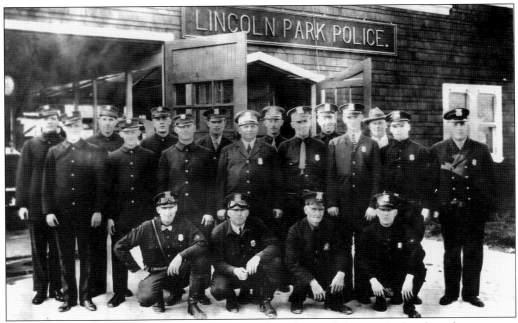

The 1926 Lincoln Park police force is pictured in front of the original police department. Seen here are Preston Tucker, Richard Barker, "Dad" York, Charles Barker, Orrie A. Hand, Frank Rohn, Roscoe Ball, Henry Krueger, Floyd Davis, Floyd Crichton, Oscar Seifert, Adolph Ferneluis, William Walton, Com Borne Sr., Frank Gillian, and Newton Rawlings. Preston Tucker (1903–1956), kneeling on the left end, was good-looking and quick-witted but not quite 17 years old when he joined the police force.

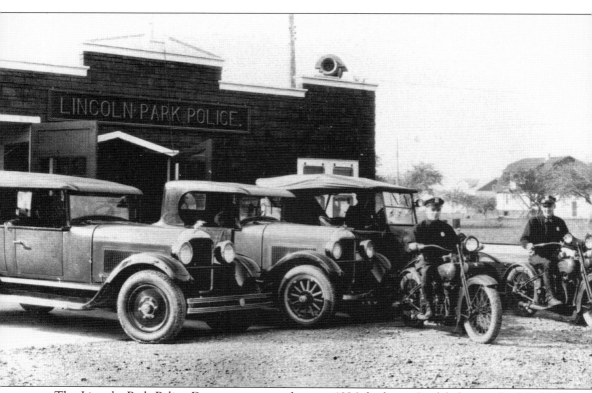

The Lincoln Park Police Department, seen here in 1926, had two Studebakers and a Model T Ford in service. The old police station stood in the center parking lot on Southfield Road across from city hall. Pictured here are Floyd Crichton (left) and Preston Tucker on Lincoln Park police department motorcycles in 1926. Tucker joined the police department against the wishes of his mother, Lucile Longprey Holmes, a Lincoln Park teacher, who eventually told village officials that he had falsified his age. Two years later, he managed to rejoin the police force but was now doing daredevil stunts on the police motorcycle. Tucker was a natural mechanic who loved to tinker with a motorcycle so that it would outrun anything and was also known to tinker with his police squad car. He is best known for riding his souped-up, police-issued Harley Davidson through the streets of Lincoln Park. Tucker's service record included several arrests of armed robbers. Crichton eventually became police chief, and he would later serve as Tucker's personal body guard during his fame as an automaker in the 1940s.

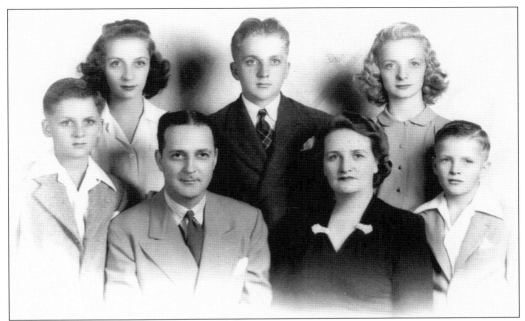

This Tucker family portrait is from the early to mid-1940s. Pictured are, from left to right, the following: (first row) are John, Preston, Vera, and Noble; (second row) Shirley, Preston Jr., and Marylee. The Tucker family lived at 1314 Warwick Street until 1940. Years later, Tucker would start the Tucker Corporation. He was best known for "the Car of Tomorrow," also known as the Torpedo or Tucker '48. The Torpedo featured a streamlined, futuristic design. The car also featured revolutionary disc brakes and a rear motor (Photograph courtesy of Tucker Historical Collection and Library.)

Preston and Vera Tucker are pictured here in the early to mid-1940s. Preston ran unsuccessfully for mayor in 1935. In 1960, Vera would sign copies of the book *The Indomitable Tin Goose* at the Sears Lincoln Park Shopping Center with Tucker's own Tucker '48 on display. William S. Mellus and Floyd Crichton stopped by for autographed copies. (Photograph courtesy of Tucker Historical Collection and Library.)

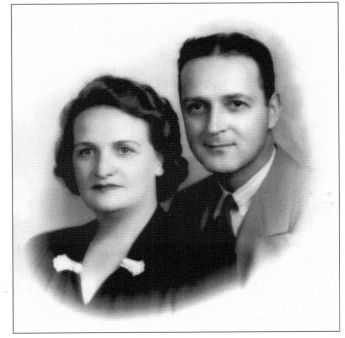

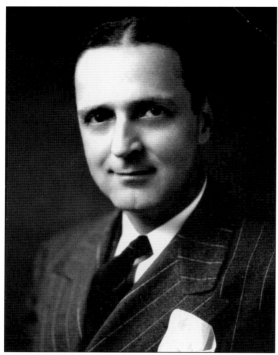

Preston Tucker, pictured here in the 1940s, was born in Capac, Michigan, but moved to Ecorse Township with his mother and brother in 1920. Prior to his police-force days, he was an office boy with Detroit's Cadillac Motor Company. He left the police force in 1928 to take a job with an automotive manufacturer. He held automotive jobs until he announced plans in 1946 to build his spectacular Torpedo. Amongst the pallbearers at his 1956 funeral were Lincoln Park's police chiefs Floyd Crichton and Henry Krueger, and retired lieutenants William Walton and Glen Tuttle. (Photograph courtesy of Tucker Historical Collection and Library.)

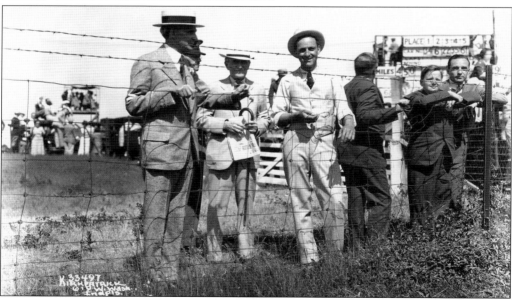

Preston Tucker is seen here at the 1932 Indianapolis 500 Speedway with the Ford and Firestone families. From left to right are Henry Ford, Harvey Firestone, Preston Tucker, Henry Ford II, Benson Ford, and Edsel Ford. Tucker met legendary race-car engine designer Harry A. Miller, and in 1935, they formed Miller-Tucker, Inc. Henry Ford was their first customer. Miller-Tucker, Inc., signed a contract to design and build 10 race cars to race at the Indianapolis 500 Speedway. The cars were built but did not meet Henry Ford's specifications. Thus, he canceled the contract. (Photograph courtesy of IMS Photos.)

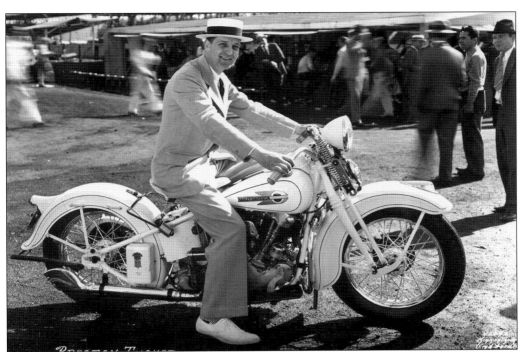

Preston Tucker tours "Gasoline Alley" at the Indianapolis 500 Speedway. Gasoline Alley is the reference people make to the garage area at the speedway where every racing team stores and works on their cars. Tucker is on a new Harley-Davidson 61 OHV model, which was a predecessor to today's Harleys. Tucker was a familiar figure at Indianapolis in the early 1930s. (Photograph courtesy of IMS Photos.)

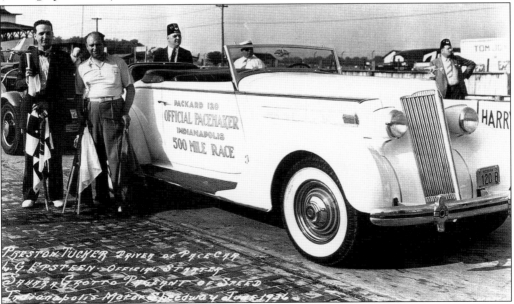

Preston Tucker is pictured in June 1936 at the Indianapolis 500 Speedway. Tucker, on the left, was the driver of the 1936 race car, and L. G. Epsteen, to his the right, was the official starter of the race.

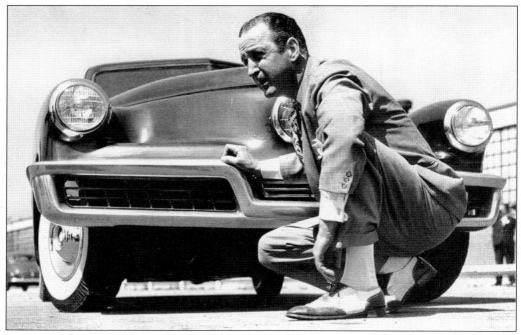

Preston Tucker is kneeling in front of the very first Tucker automobile. This photograph was taken on June 18, 1947, at the Chicago plant following the unveiling. By 1940, the Tucker family had moved to Ypsilanti. In 1946, Preston Tucker helped launch the Ypsilanti Machine and Tool Company to make automotive parts. He started working on a teardrop-shaped, aerodynamic luxury sedan with a top speed of 130 miles per hour. (Photograph courtesy of Tucker Historical Collection and Library.)

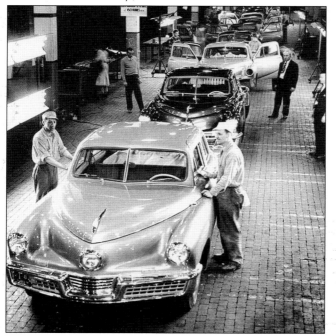

This is a 1948 photograph of the Tucker assembly line in progress at the Chicago factory. Tucker recruited visionary designer Alex Tremulis. The Tucker is loaded with various safety features and new technology. The War Assets Administration leased Tucker a Dodge plant in Chicago that had been used to build aircraft engines during the war. Problems occurred when one of the first Tuckers collapsed on its suspension minutes before being unveiled to the public and dealers in June 1947. Unfortunately, the assembly line had to be shut down in 1948 after 51 Tuckers, including the prototype model, were built. (Photograph courtesy of Tucker Historical Collection and Library.)

Seven

A 20TH-CENTURY MELTING POT

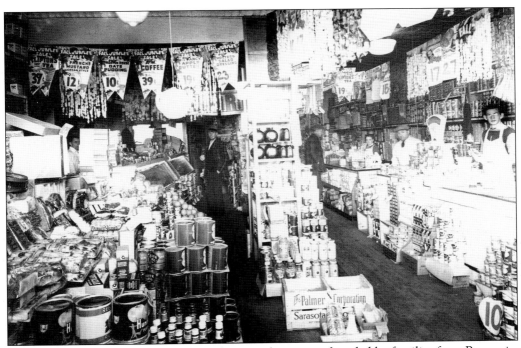

The Fort Park and Garfield corner was home to businesses founded by families from Roccapia, Italy. Roccapia, a small town off the Adriatic coast, is nestled between two mountains 80 miles west of Rome. The Chiarelli, Clemente, and Leone businesses all occupied this corner. Chiarelli's Market, which opened in the 1920s, still operates on Fort Park. Joe and Natalina Clemente opened Italian Village Inn in this building, but the name was changed to Clemente's due to the impeding war. In 1933, they were the first Downriver restaurant to get a liquor license. The Fedea, Cioccio, and Perfetto families also came to Lincoln Park from Roccapia, Italy.

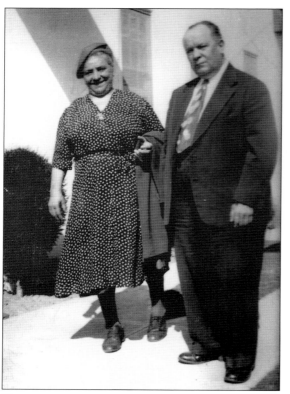

Giussepi "Joe" Clemente Sr. and Natalina Di Santo Clemente came to the United States from Roccapia, Italy. Joe arrived in 1916 to find work in Pennsylvania, but World War I interrupted his plans to bring his family to the United States. Finally, in 1924, Joe was able to bring Natalina and their young son, Ettore "Big Ed," to the United States through Ellis Island. They settled on the east side of Detroit, off Chene, near the Eastern Market. The Clemente family came to Lincoln Park in 1928 and opened a pool hall on Fort Park at Garfield.

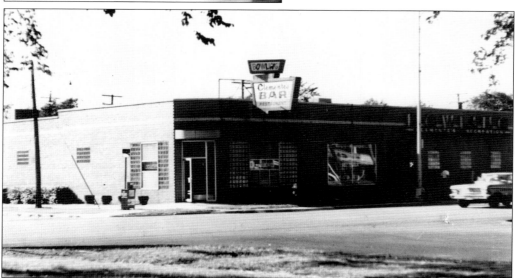

After World War II, Joe Clemente Jr. returned home from the Marines. In 1946, they built a new location at 2230 Fort Street, which included a tavern and restaurant. The restaurant space was leased to a restaurant called the Everglades. At this point, Clemente's is a tavern with food. In 1947, they opened a dining room in the former Everglades restaurant. Bowling was then popular, so a six-lane bowling alley with manual pinsetters opened in 1948. At the same time, Clemente's decided to offer pizza to go with the bowling. In 1955, automatic pinsetters were added.

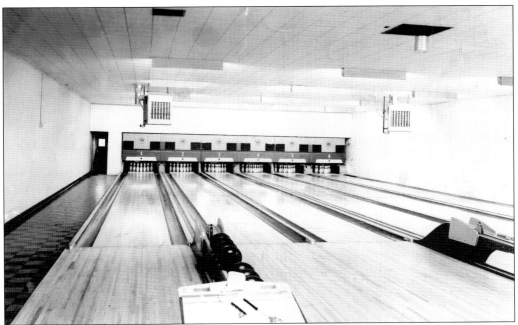

The bowling alley at Clemente's, on 2230 Fort Street, featured six lanes. By the mid-1950s, the first automatic pinsetters were introduced, known in the bowling industry as "8230s." This image shows the Clemente's lanes with the 8230s. During the 1950s, indoor sports such as bowling were popular. It was an era minus competition from cable television, computers, hi-tech stereos, video games, and so forth. Clemente's pin-setting equipment would continue to be upgraded as the bowling industry introduced new technology. Throughout the years, Clemente's proven strength has been a small, family-oriented atmosphere in a niche market.

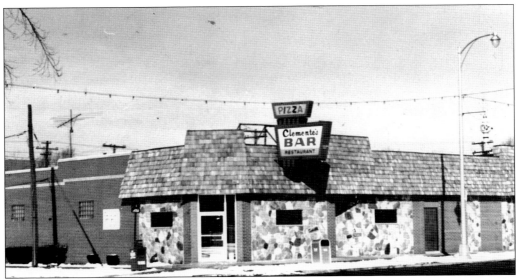

This is a current view of Clemente's Bar Restaurant and Bowling Alley at 2230 Fort Street. The building was renovated with a cedar-shingle roof overhang and exterior stone walls in 1971. Notice the cool vintage sign that reads "Pizza" on one side and "Cocktails" on the other.

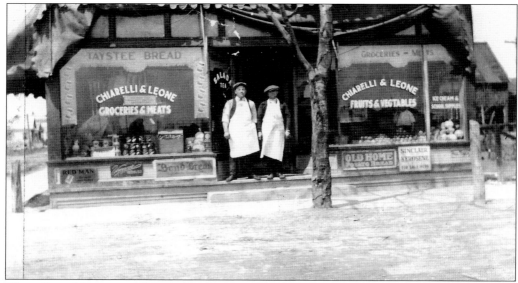

Chiarelli and Leone was founded by Ercole "Charlie" Chiarelli and Romeo "Shorty" Leone in 1925 at 2116 Fort Park Boulevard. The building was owned by the Clemente family. Fort Park at the time was still a dirt road. The storefront windows advertise their products: groceries, meats, fruits, and vegetables, as well as name-brands like Taystee Bread. The roll-out awning protected passersby during the hot, sunny part of the day.

In 1928, Chiarelli and Leone's Market moved into a new building at 2210 Fort Park. The old market was then turned into the first Clemente's Bar. In 1935, Charlie Chiarelli bought out Shorty Leone. The market is now known as Chiarelli's Market. In the early days, the market kept ledger books of its customer accounts. On payday, customers would come in to pay their bill. Charlie Chiarelli would give free bags of candy to his customers for their children. In 1951, an addition was added for more space.

Charlie Chiarelli came from a mountainous section of Italy near Rome. He settled for a short time in California but made his way to Chicago, where he decided not to stay because that was the time of Al Capone, guns, and gangsters. Charlie came to the Detroit area to join friends and family, getting a job as a machinist for the Dodge Brothers. In 1924, after only six months on the job, he severed two fingers. Dodge gives him a $500 settlement, which he used to start Chiarelli and Leone's Market with Shorty Leone. There Charlie met customer Clara DeSanto, who had recently came from Roccapia, Italy. They married in 1928 and lived above the market in an apartment, where sons Frank and Al were born in 1929 and 1932, respectively. The pastas and Italian sauces were homemade by Clara Chiarelli.

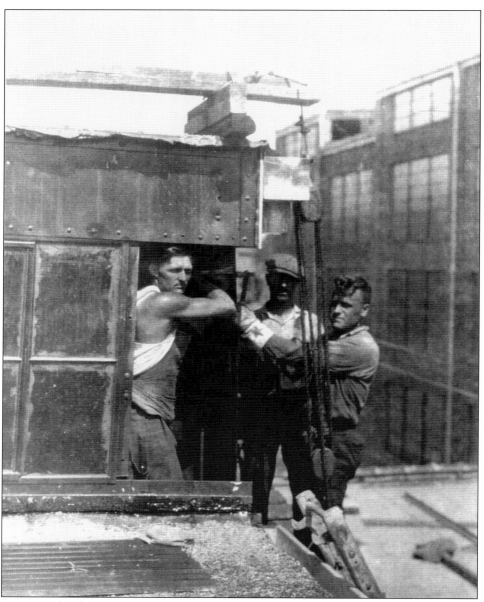

John A. Papalas (left), born on the Greek Island of Ikaria in 1895, came to the United States in 1911. For the next 19 years, he worked in construction, traveling from city to city across the country. Papalas worked his way up to become foreman of a painting crew in Ohio before coming to the Downriver area in the 1930s to work on a construction job at the Great Lakes Steel plant in Ecorse. Papalas decided to settle down and selected a site at Empire and Montie Streets in Lincoln Park. He established his industrial roofing and painting firm, which grew over the years to 100 to 150 employees. Papalas took a deep interest in the Lincoln Park community and the improvement of recreation facilities. He was a sponsor of baseball, softball, bowling, and other athletic teams, and he donated equipment and uniforms for the children and young people of Lincoln Park. He was fond of the Little League baseball program and donated a huge tract of his land adjacent to his home for a baseball diamond.

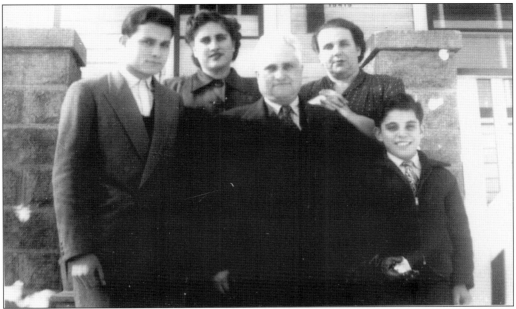

After the arrival of John A. Papalas from the Greek Island of Ikaria, other Ikarian Greeks followed. Pictured here is the Moraitis family, who came to Detroit after World War II for better opportunities. From left to right are John Moraitis, Kelly Moraitis, Nick Moraitis, Katina Moraitis, and Ted Moraitis. John and his wife, Toula, moved to Lincoln Park in 1962. In 1976, they opened Park Restaurant. Today John and Toula manage the restaurant along with their son Eleas.

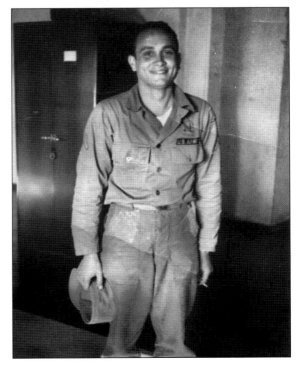

John Moraitis is pictured as a young Army serviceman in Germany during the 1950s. Although he came to the United States in the late 1940s from Greece, John was drafted in 1956.

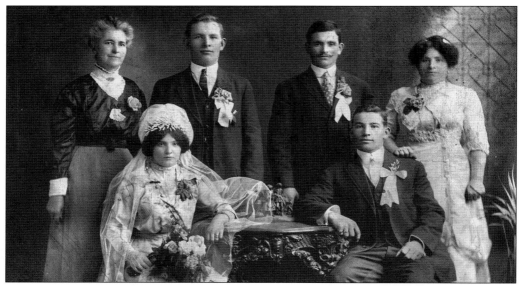

Eastern Europeans came to the United States by way of Ellis Island and settled in Detroit's Delray neighborhood in the early 20th century. Hungarian, Polish, and Armenian immigrants came to Delray to be close to the factories that employed them. Pictured here is the wedding party of Charles and Rosalie King, who were married in 1914 in St. Catherine's Church in Ontario, Canada. Charles King's Hungarian surname, Kiraly, was anglicized to King when he came to Canada from Hungary. In 1916, the King family immigrated to Detroit due to Canada's internment of Hungarian nationals during World War I.

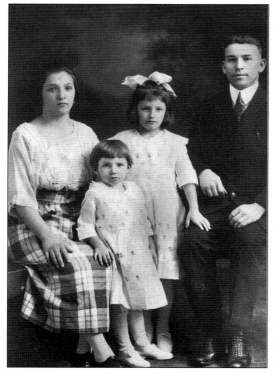

After World War II, Hungarian families started moving to Lincoln Park from Delray for the better opportunities of new schools and homes. After the Hungarian Revolution of 1956–1957, many more Hungarians came to Lincoln Park. Pictured here is the family of Charles and Rosalie King, who lived in Delray until the early 1940s when they moved to Lincoln Park. Pictured, from left to right, are Rosalie King, daughter Helen, daughter Mary, and Charles King. Mary King Cibor is an active Lincoln Park Historical Museum volunteer who moved to Lincoln Park about 35 years ago from Detroit.

Many Slovaks came to the United States in the early 20th century because there was little opportunity in what was then the Hungarian-dominated region of the Austrian-Hungarian Empire. The United States needed labor for Pennsylvania coal mines and Midwest factories. Many came to southwest Detroit, Lincoln Park, after World War II. Pictured here is Jan Maruska, who had come in 1922, settling in Uniontown, Pennsylvania. Working as a coal miner, he managed to save up money so that his wife, Emelia, could come over in 1928. Jan and Emelia eventually settled in southwest Detroit. Jan Maruska found employment at Ford Motor Company.

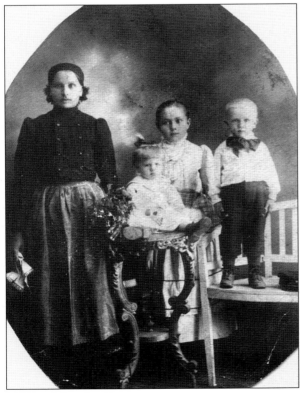

Pictured here, from left to right, are the following: (back) Emelia Uskert Maruska and her sister Julia Uskert; (front) Emelia and Jan Maruskas' kids Margaret and Jan Jr. Jan is the Eastern European spelling of John. In 1951, the Maruska family moved to Lincoln Park, which was considered the Cadillac of cities. Today the Maruskas' grandsons are Lincoln Park residents: Edward Zelenak, city attorney and honorary Slovakian consul; David Zelenak, court judge; and Patrick Zelenak, Safety Commission board member. Forty thousand Slovaks reside Downriver, of which many remember the years of communism. In 1993, Slovakia split peacefully from Czechoslovakia, becoming a democracy.

Detroit's expanding industrial base, such as Henry Ford's "$5 a day," attracted workers from Latin America. By the 1920s, Detroit was home to 15,000 Hispanics who had settled near Michigan Avenue in Detroit's Corktown. Due to the 1930s Depression and a U.S. repatriation program, Detroit's Hispanic population dropped drastically. By the late 1930s, the Hispanic population rebounded. With the outbreak of World War II, immigrants came to work in Michigan's agriculture and Detroit's assembly lines. However, with the introduction of the freeways, the southwest Detroit neighborhoods were uprooted. The 1940s John Lodge Freeway construction and the 1960s Fisher Freeway disrupted the Hispanic community, dividing the residential and business districts. The new freeways pushed the displaced community farther into southwest Detroit neighborhoods as well as Downriver communities. Pictured here are Mexican American Lincoln Park fire chief Gilbert Solis and his father, Zeferino Solis. Zeferino Solis, a World War II veteran of D-day, moved his family here in 1958 from the southwest Detroit neighborhood of Vernor and Central. Zeferino Solis wanted his family to avoid the stress of the inner city and to have a better life of new schools. (Photograph courtesy of Don Van Cleave.)

Eight

PUBLIC SCHOOLS

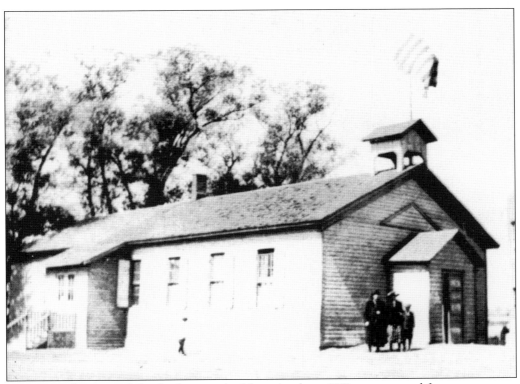

The original Strowig School, photographed here in about 1921, was a wood-frame, one-room schoolhouse named after Frederick Strowig. Frederick Strowig was a German immigrant and successful farmer who, in 1850, donated a tract of land to Ecorse Township officials for the sole purpose of erecting a school. The school was located on Pepper Road, now Outer Drive, as part of the Ecorse Township school system known as District Five. In 1921, the old school was moved to Fort Street in what is now known as southwest Detroit so that a larger, modern brick school could be built on the site.

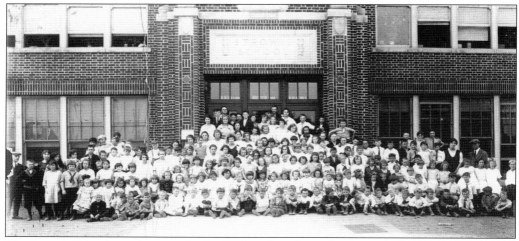

The Strowig School was photographed in 1922, with students, faculty, and Mr. Scott, the principal. Strowig School was built in 1921 as a modern brick structure with four classrooms. Two of the three Ecorse school districts were located in Lincoln Park at this time: Ecorse district No. 5, which included Visger Road in Detroit to State Street (Southfield Road), and Ecorse Township district No. 10, which included residents from State Street to Goddard Road. The Strowig School was sold to Wayne County, which demolished it in 1926 to make room for the widening of Fort Street.

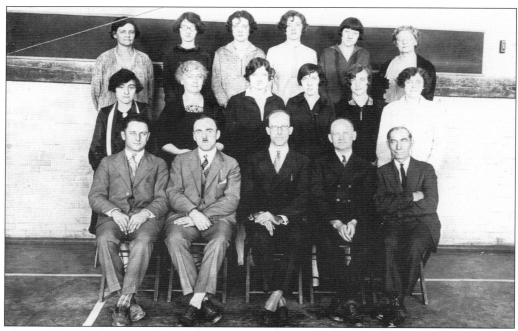

The Strowig School staff of 1926–1927 included, from left to right, the following: (first row) Theron Vande Walker, Robert Reeves (principal), Justin Morrison (superintendent of schools), Herman Boldt, and Benjamin G. Sutton; (second row) Blanche Gochinaur, Mrs. Hicks, Martha Kern Kleinhans, Muriel Derrin Hanlet, Hazel Roulo Foster, and unidentified. The third row includes Margaret Longprey, Zelma Mitchell Kern, Gene Mitchell Derr, and Mrs. Johnson.

The original Goodell School was a wood-frame, one-room schoolhouse that was built in the 1870s. It was located at about where Fort Park Boulevard and Lincoln Street meet, on land obtained from Toddy Beaufort. Up until it was built, children were taught in Samuel LeBlanc's home. The school was named for Cleophus Goodell, a member of the school board and a descendant of the first English-speaking family in the Downriver area. Louise Mackey was the first teacher. It was part of the Ecorse Township district No. 10.

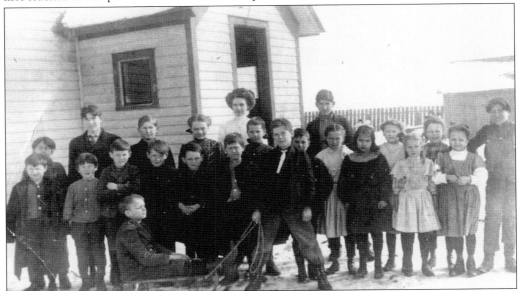

Students and teachers are pictured in front of the original one-room Goodell School in the early 20th century. Supplies for the school included a big map on an easel, a globe of the world, a Webster's dictionary, a stove with a supply of wood, a water pail and dippers, a broom, six erasers, and two boxes of chalk.

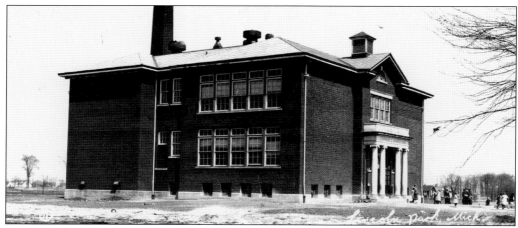

Eventually the wood-frame Goodell School became too big for the site and the schoolhouse was moved to a large site on Champaign Street that was previously owned by Joseph Bondie. The school was replaced with a new brick building in 1918 at the corner of Fort and Champaign Streets, with four classrooms. Two additions, a gymnasium and an auditorium, were later added to the building.

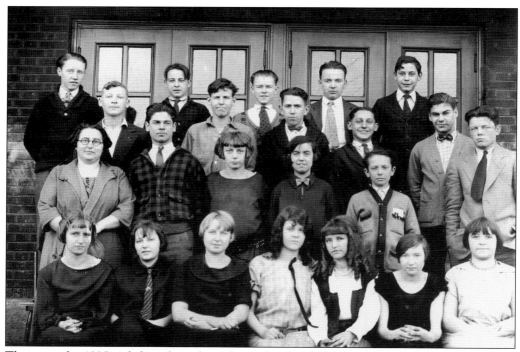

These are the 1925 eighth and ninth grades at the Goodell School. Pictured from left to right are the following: (first row) Mildred Nass, Lottie Partow, Sophia York, Josie Nick (McGuire), Estelle Sheridan, Florence Dean, and Anna Angiolet; (second row) Priscilla Hoopher Debuck (teacher), Louis Angiolet, Dorothy Nass, Beatrice Sterline, Charles Gaines, and Ethridge Knick; (third row) Charles David, Charles Kine, Raymond Pilon, Charles Schropp, and Calvin Robinson; (fourth row) Gordon Brown, Robert Shankie, Ellsworth O'Neil, Dalesford Parthran, and Owen Crowhurst.

The Goodell School is pictured here in 1926. During this year, a high school was started with the ninth grade. Priscilla Debuck was placed in charge of this group of students. The Goodell School was closed on June 23, 1971. The building was demolished, and the school bell was given to the Lincoln Park Historical Museum. The bell now hangs from a bell tower located in the side yard of the museum. Every New Year's Eve at midnight, the bell is rung to welcome in the New Year.

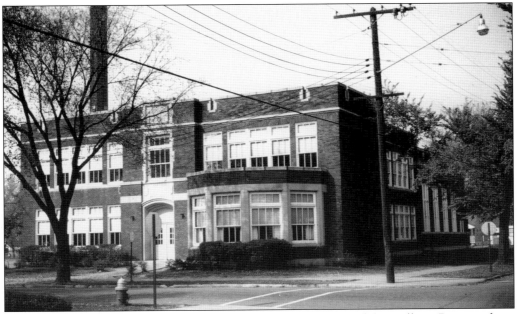

Raupp School, at 1351 Ethel Street, was built in 1921 and named for William Raupp, whose family members were early settlers in the area. Raupp was the first village president as well as the first mayor when Lincoln Park was incorporated in 1925. He served on the school board from 1927 to 1933. The school opened for classes in January 1924 with Arnold Gregory, age 19, as its first principal. Arnold Gregory spent from 1923 until 1941 at the Raupp School. The school had the first high school class that included ninth grade students from Strowig. The school was replaced with a new school in 1999.

The Horger School is pictured here in 1950. Horger was built in 1922 and named for B. W. Horger, who had platted the Horger subdivision. B. W. Horger had donated the site for the school with a provision that the building bear his name in recognition of his gift. The first principal was Lyman Galloway, who served from 1925 to 1928. The building was demolished in 1999.

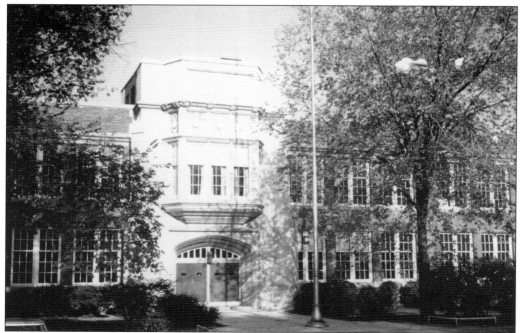

Lafayette School, at 1360 Lafayette Street, was built in 1926. Robert L. Reeves was the first principal, serving from 1927 to 1928. The high school was held in the Lafayette School second floor from 1928 to 1933, with Earl F. Carr as the principal. A new one-story school was built on the site in 1997 and opened for classes in 1998. The old school was demolished in 1998.

Hoover School, at 3750 Howard Street, was built in 1930 due to the successful passing of a bond issue in 1928. Joseph G. Kastler was the architect and W. W. DeLange Company was the general contractor. The school was named after Pres. Herbert Hoover, with Howard Derr as its principal. Derr served from 1930 to 1966 at Hoover. Leo Huff was the superintendent of schools. The Lincoln Park Board of Education included Winfred L. Crowley (president), Albert J. Flynn (secretary), and Robert B. Hamilton (treasurer). Trustees were May V. Smith, Paul W. Bensnyder, William Raupp, and George Shanley.

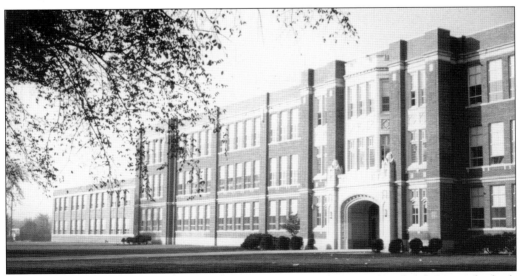

The Huff Junior High School was built in 1930 as Lincoln Park High School. It was the high school from 1933 to 1959. Lincoln Park High School was the first Michigan high school to be recognized by the University of Michigan before being accredited by the North Central Association. Earl Carr was the principal from 1933 to 1941. The school was named for Leo W. Huff, who was the first superintendent of schools from 1928 to 1956. Cliff Underwood was the principal of Huff Junior High from 1960 to 1965. The building was demolished in 1981.

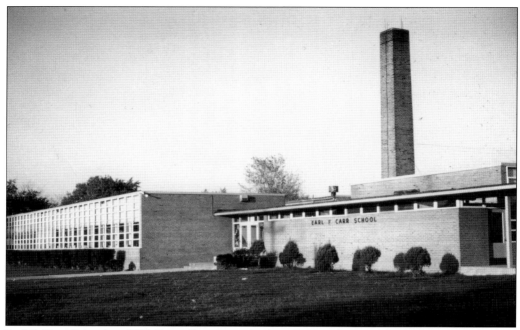

Earl F. Carr School, at 3901 Ferris Street, was built in 1950 and named for Earl F. Carr, who had served as principal of the Goodell School since 1921. Earl Carr moved to Lafayette High in 1928, then to Leo Huff High School, which later became Leo Huff Junior High. The first principal was Vesta Hubbell, who served from 1949 to 1969.

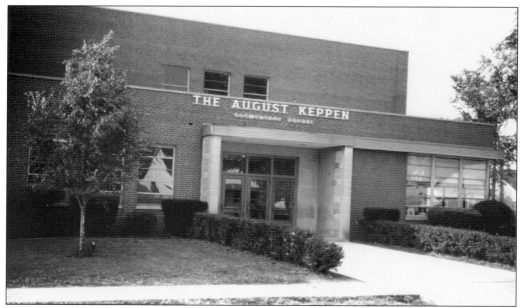

August Keppen School, at 661 Mill Street, was named for August Keppen, a pioneer farmer who came to the community in the mid-19the century. Mr. Keppen served on the early school board. The school was built in 1951 with Lawrence Shilling as its first principal and serving from 1941 to 1967.

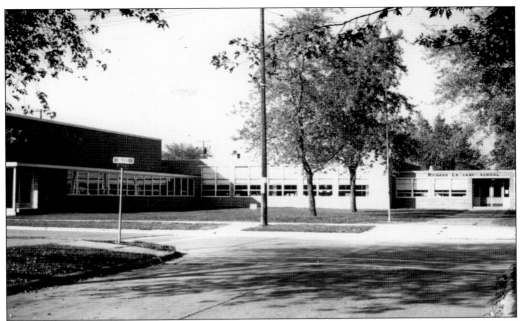

Richard LeBlanc School, at 3804 Hazel Street, was named for Richard "Uncle Dick" LeBlanc, who was the oldest resident in Lincoln Park. The LeBlanc family members were early settlers of Lincoln Park. The school was built in 1951 with Archie Cairns as its first principal, serving from 1951 to 1953. It eventually ceased to be used as an elementary school and opened as a special education center.

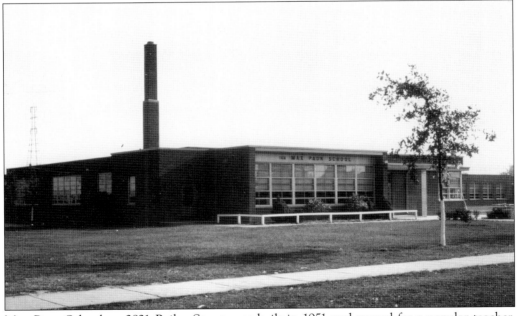

Max Paun School, at 2821 Bailey Street, was built in 1951 and named for a popular teacher, coach, and principal of the Goodell School. Ezra Roberson was the first principal and served from 1951 to 1974.

The May V. Smith School at 1650 Champaign Street was built in 1952. The school had 330 students. Located on the corner of Champaign and Howard Streets, the school soon served both physically disabled and mentally impaired students. May V. Smith was an early resident of the area. As a PTA Council president, she served on the school board from 1927 until her death in 1947. The building eventually ceased being used as a school and was renovated to be the board of education office.

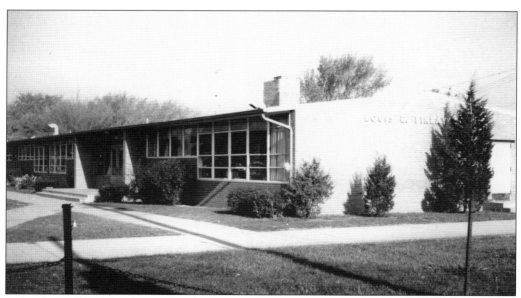

Louis E. Findley School, at 2060 Council Street, was built in 1952 and named for the Lincoln Park High School bandmaster. Louis E. Findley was the first instrumental music teacher and the first high school band conductor. This school was an annex to Horger School and housed grades kindergarten through three. Thero C. Vandawaker was the first principal and served from 1955 until 1971. The building was closed in 1971 and sold.

James Foote School, at 3250 Abbott Street, was built in 1953. The school was named for Dr. James Foote, a Lincoln Park physician and school board member. Its first principal was Archie Cairns, who served from 1953 until 1966.

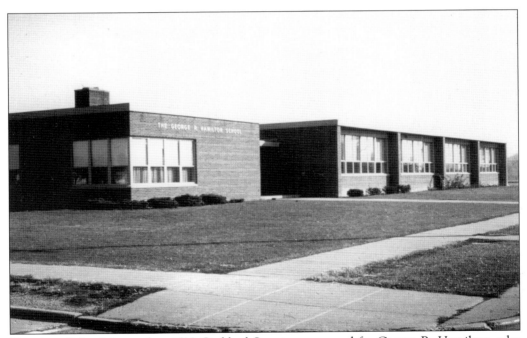

Hamilton School, located at 1590 Goddard Street, was named for George R. Hamilton, who served on the first village school board. The school was built in 1955 with Nina Wilson as the first principal. She served from 1955 until 1960. This school closed in 1975 and is the location of alternative high school programs and adult education classes.

Frank G. Mixter School, at 3301 Electric Street, .was built in 1956. This school was named for attorney and civic leader Frank G. Mixter. Arthur Quinn was the school's first principal, serving from 1956 to 1974. Also named in honor of Frank G. Mixter was the Mixter Medal, which was established in 1928 to honor Lincoln Park High School male graduates who were selected by students and faculty for combined scholastic and academic accomplishments.

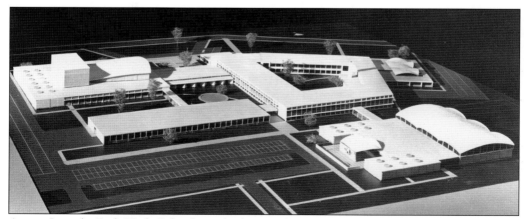

A new Lincoln Park High School was built in 1957 at 1701 Champaign Street, with Arnold Gregory as the first principal from 1960 to 1963.

Winfred S. Crowley School was named for Winfred Crowley, a realtor, who served on the school board from 1927 to 1967. The school was built in 1959 with Nina Wilson as the first principal, serving from 1960 until 1965. The school closed in 1971 but is currently being used by Head Start.

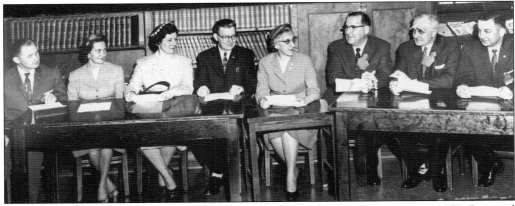

This image depicts a panel at a Lincoln Park High School visitation session in 1950. Pictured from left to right are unidentified, Eleanor Wiess Moore, Mary McElroy, Edwin Jones, Helen Van Horn, Arnold Gregory, James Green, and unidentified.

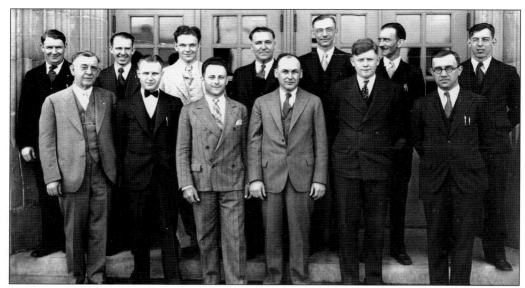

Pictured from left to right are the following: W. J. Brubaker (truancy officer), Ray Norsworthy (Lincoln Park High School science laboratory teacher), Arnold Meyer (teacher), Arnold Gregory (Raupp School principal), Howard Derr (Hoover School principal), Walter Gibson (Lafayette School principal), Lawrence Shilling (Lincoln Park High School industrial arts teacher), Earl F. Carr (Lincoln Park High School principal), T. C. Vanderwalker (Horger School principal), Leo Huff (Lincoln Park school superintendent), Everette Winslow (Lincoln Park High School biology teacher), and Lyman Galloway (Horger and Raupp Schools principal).

The Lincoln Park public school staff is pictured here in 1924. Shown from left to right are the following: (first row) Mrs. Artman, Miss Dennison, Zelma Mitchell, Miss Burba, Miss Chatel, and Geneva Mitchell; (second row) Mr. Morrison (district No. 5 superintendent of schools), Mrs. Baldwin, Miss Valerio, Miss Gochinaur, Miss Rehn, Miss Lang, Miss Roulo, Miss McCoy, and Principal Reeves (Lincoln Park High School district No. 5); (third row) Mrs. Johnson, Mrs. Carr, Mrs. Longprey, Miss McDonald, Mrs. White, Mr. Scott (Strowig School principal), Mr. Vande Walker, Mr. Sutton, and Mr. Boldt; (fourth row) Mrs. Hicks, Mrs. Scarlette, Miss Phillips, Miss Senick, and Arnold Gregory (principal of Raupp School).

Nine

BUSINESS AND MUNICIPAL GROWTH

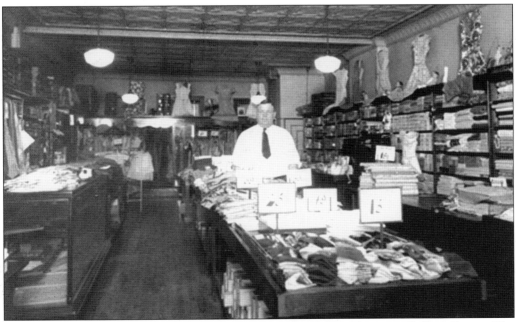

Joseph and Ruth Blumrosen's Economy Store was at 1184 Fort Street at College Street. The Blumrosens started their dry goods store in 1925. They were involved in many Lincoln Park organizations. Joseph Blumrosen was instrumental in obtaining a library for Lincoln Park, and Ruth Blumrosen was a charter member of the Lincoln Park Women's Club, as well as part of its garden division. The Blumrosens were avid rose gardeners. Their home at 1410 Keppen Street was home to a lovely rock garden, over 500 rosebushes bearing more than 200 varieties, as well as approximately 2,000 tulips.

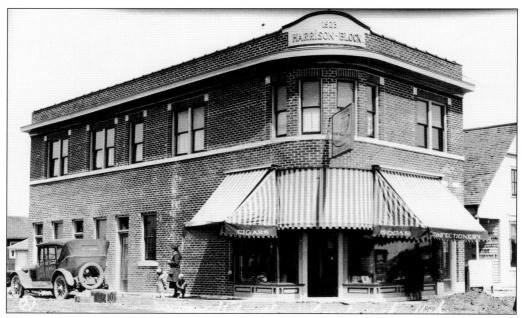

This building on State Street, now Southfield Road, was known as the Harrison Block. Its owner, Floyd Harrison, was the first village clerk and first city clerk of Lincoln Park. He served as council president from 1929 to 1931 and began a dozen years as city treasurer in 1936. Harrison had an insurance business, was active in the American Legion and the Masons, and was the state president of the Exchange Club. He also ran unsuccessfully for mayor.

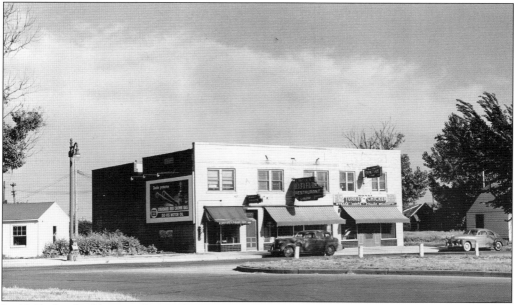

In 1941, this building at the southeast corner of Fort Street and Southfield Road housed the Staley Barber Shop and the Lucas Bar and Restaurant. Today the well-maintained structure looks much the same, with a hair salon and Central Work Clothes on the ground floor and apartments above.

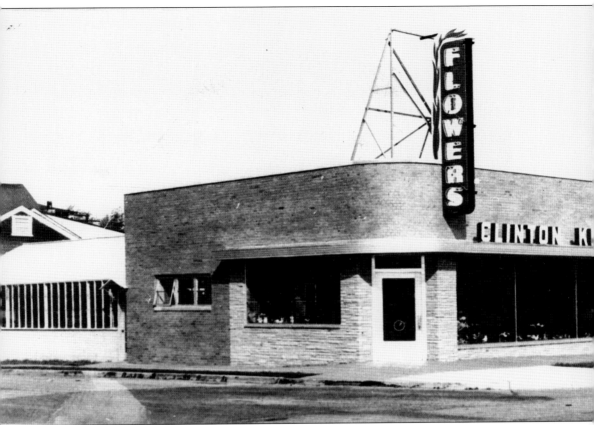

For decades, this flower shop has grown and evolved at 1382 Fort Street. This view shows the familiar neon sign that still casts a warm glow on the northwest corner of Fort and Hanford Streets. The Clinton Knoch Florist was founded in 1929 by Clinton Knoch (1894–1981). He bought out the Nieman's Flowers shop at 1415 Fort Street. Clinton Knoch was the son of Detroit florist Gus Knoch, whose parents were horticulturists in the Woodmere Cemetery area in the 19th century. Clinton Knoch moved the flower shop to 1382 Fort Street in 1936. In the mid-1950s, when Clinton Knoch retired to California, the name was changed to Flowers by Ed Lobb, as son-in-law Ed Lobb took over. In 1976, Ed Lobb retired and son Dan Lobb became the owner-manager. The name was changed to Flowers by Lobb.

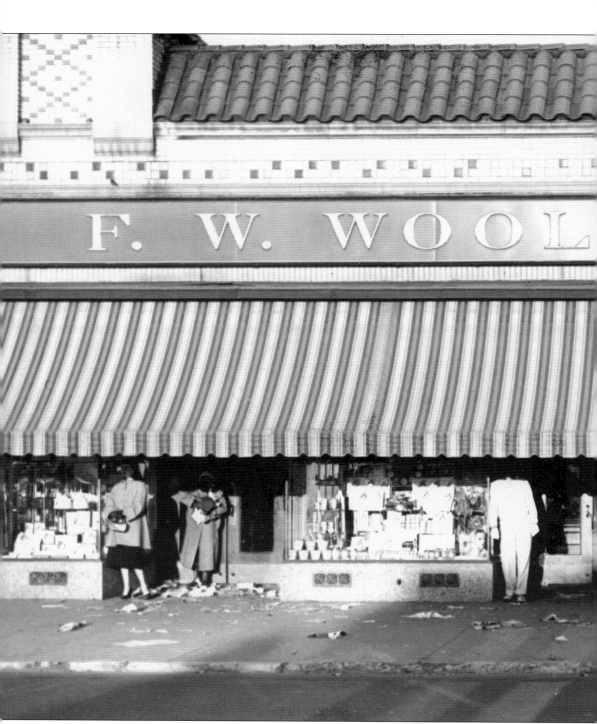

The F. W. Woolworth dime store was thriving at 1770 Fort Street on the northwest corner of Southfield Road in 1951. More recently, an insurance business occupied this building. This Spanish Mission Revival–style building, built in 1930, is intact. This store was one of two dime stores in Lincoln Park; Neisner's was the other. Virtually any main street in America had a Woolworth's

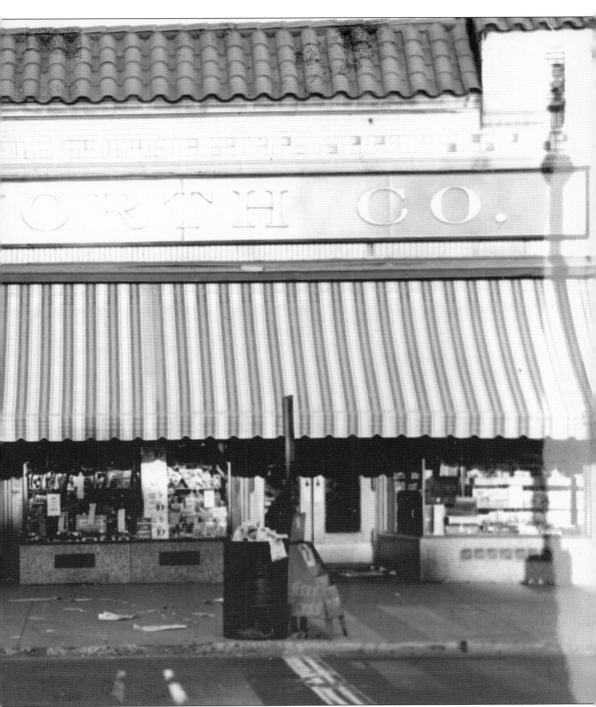

in the first half of the 20th century. Woolworth's offered a wide assortment of affordable items and was one of only a few national chains during these years. With its lunch counters, it was the nation's largest food-service retailer. F. W. Woolworth revolutionized retailing. Prior to his stores, shopping meant bartering, and merchandise was hidden behind counters.

In 1925, Lincoln Park's first year as a city, Mother's Restaurant was a dining option. Mother's was at the corner of Fort and Warwick Streets. Many Lincoln Parkers fondly refer to it today as the "pig stand." They had your typical lunchtime menu of soup and sandwiches. It was owned by Dorothy Crombie, Mary O'Connor, and Nellie Etchell.

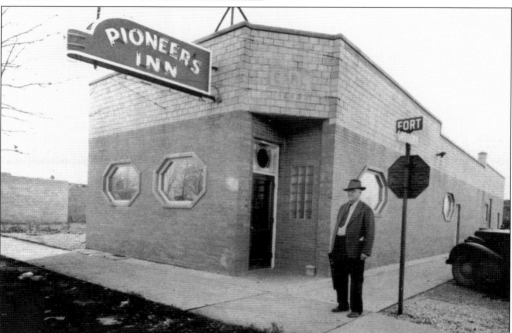

Earl Bernethy's Pioneer's Inn, on the southwest corner of Fort and Gregory Streets, was built in 1945 by Earl Bernethy. It is now called Route 66 but still retains its original exterior. Over the front door it has "Earl" and "1945" carved in the block.

This was Johnson's store as it appeared in 1923. Johnson's carried staples such as bread and coffee.

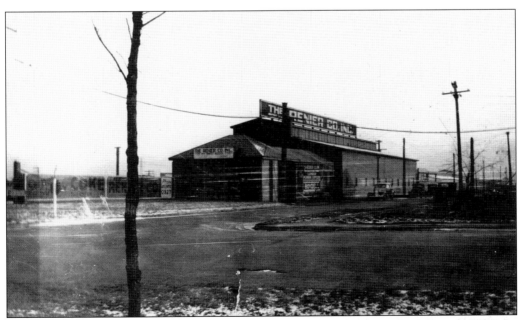

The Renier Company, on Southfield Road at Howard Street, is shown here in early 1948. Its Lincoln Park lumberyard opened in 1926 and grew with the city. It was started by Camillius J. Renier. In 1928, his father, Julius, and brother, Joseph, joined him in the business. By the 1960s, it was a complex of 12 buildings, offering all kinds of building and home-improvement supplies. Much of its property was taken for I-75, and later a scrap yard operated on what remained of the site. A modern, tri-level self-storage facility is there today.

Ron Gahan managed the old Kroger store on Fort Street. It was next to the Gardner Drug Store and Soda Shop, which occupied the southwest corner of Fort Street and Southfield Road.

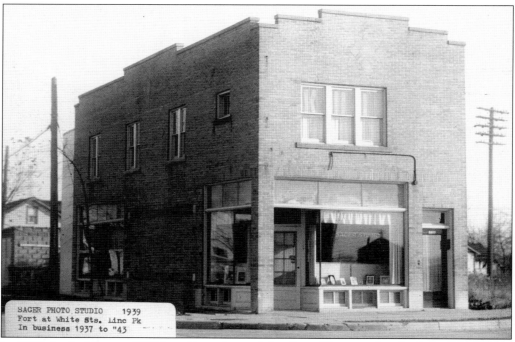

SAGER PHOTO STUDIO 1939
Fort at White Sts. Linc Pk
In business 1937 to "43

In 1939, the building at 2205 Fort Street housed the Sager Photographic Studio, which was in business from 1937 to 1943. After that, Morris Sager continued to document the evolution of Lincoln Park.

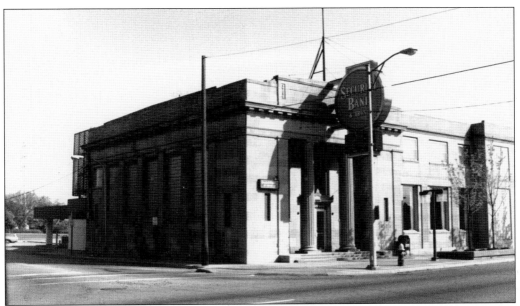

The 1923 neoclassical bank at Fort and O'Connor Streets still has a commanding presence in downtown Lincoln Park. Originally, the Lincoln Park National Bank, it is now a branch of National City Bank, which has made major repairs to its Indiana limestone exterior. The architectural firm of Maul and Lentz has its name proudly engraved in the entryway. In 1947, an addition was added on to the original bank. Over the years, the bank name changed to State Savings Bank of Lincoln Park, Ecorse Lincoln Park Bank, Security National Bank, and National City Bank.

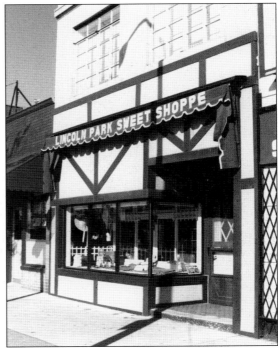

Confectioner Pasquale "Patsy" Pacione ran the Lincoln Park Sweet Shoppe along with his wife, Mary. In its early days, hand-dipped chocolates, penny candy, and other sweets were sold. Later breakfast, light lunches, and ice cream were served at its lunch counter. The shop also sold cards and gifts. Lincoln Park Sweet Shoppe started out in 1925 in space adjacent to the Park Theater. In 1939, the business was moved to 1570 Fort Street. It is shown here in 1987, after over 50 years in business. This building at 1570 Fort Street still stands.

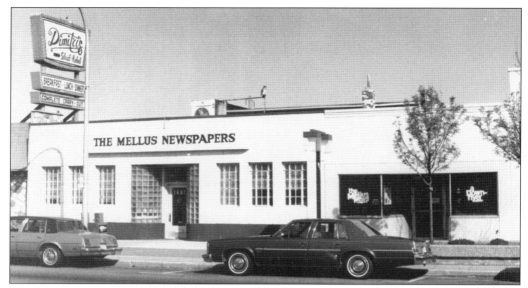

The structures at 1661 and 1667 Fort Street for many years served as headquarters of Mellus Newspapers. The Mellus Newspapers were started in 1933 by William S. Mellus. In 1986, they were bought out by Heritage Newspapers. The main building at 1661 Fort Street, shown here in 1987, was built in 1941 in the Streamline Moderne style. The building at 1667 Fort Street, previously known as Pollak Jewelers, was run by Isidor Pollak. The Mellus complex awaits restoration or redevelopment. The tall sign at the left, from the former Dimitri's Restaurant, is now Ray's Coney Island.

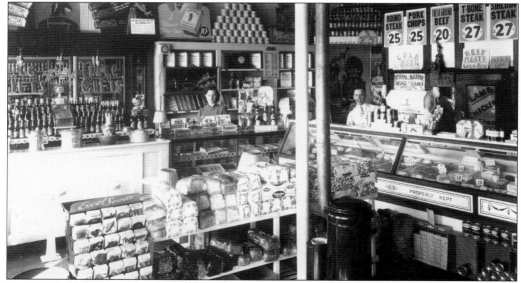

Karol Grocery Store, pictured here in its early years, carried groceries, meats, ice cream cones, and penny candy. It also featured a soda bar. Michael "Mickey" Karol, a Ukraine native, and his wife, Edna, ran Karol Grocery at 2205 Fort Street and 2215 Fort Street, their second Lincoln Park store, until 1973. The Karols earned a reputation for treating customers fairly and refusing to sell tobacco to minors. A sign displayed in the store read their business philosophy: "Price is soon forgotten, but the memory of good will, honesty and quality last forever."

Claude and Lois West came to Lincoln Park with four children in the early 1940s. Claude's Barber Shop served the area throughout the 1950s and 1960s. Claude's Barber Shop was located at 1458 Dix Avenue.

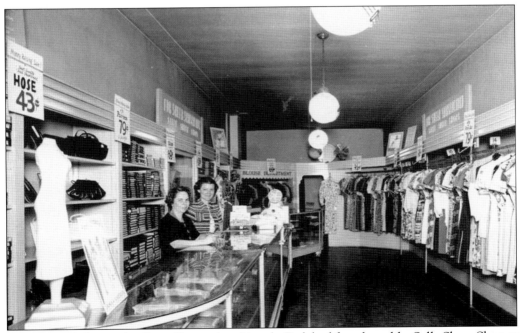

Even in 1936, during the Great Depression, Lincoln Park had fine shops like Sally Sheer Shop at 1724 Fort Street near Arlington Street. Sally Sheer Shop was a women's lingerie shop.

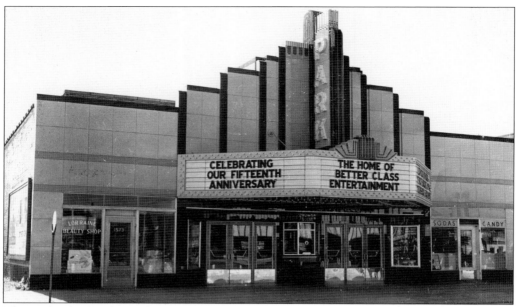

The Park Theater, located at 1583 Fort Street, was renovated in 1936 with this Streamline Moderne façade. The original marquee and canopy were replaced with a porcelain steel, vertical marquee. The Park Theater was a social center. During Christmas 1934, at the height of the Depression, the theater manager issued free admission tickets to those who could not afford them. In 1939, tickets were given to dignitaries in town for the dedication of the new post office. During World War II, the theater was used as a campaign headquarters to raise money for war bonds.

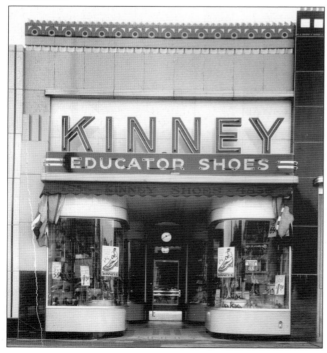

Kinney Shoes, once a leading national chain, had this Fort Street shop in 1954.

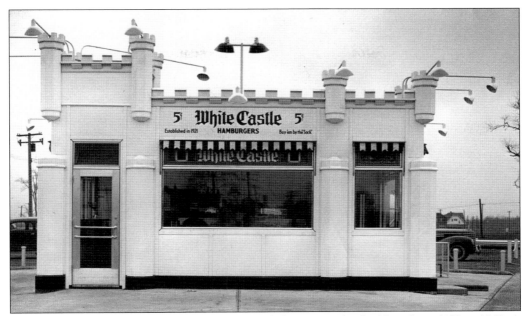

Lincoln Parkers got the famous little White Castle burgers in this building from 1953 to 1962. A newer White Castle now serves at 2115 Fort Street, the same location as the old White Castle.

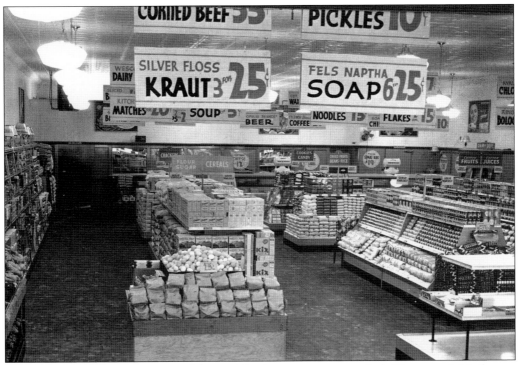

In 1958, Jack Cinnamon ran one of the city's leading grocery stores, Jack Cinnamon's Markets at 2106 Fort Street. The store sold groceries and meats. You can still see faint evidence of a painted sign on the building. The building is now Empire Furniture.

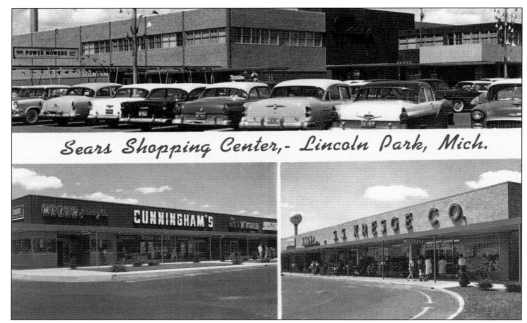

This 1954 postcard shows scenes of the Sears Shopping Center in Lincoln Park, which caused a sensation when it opened at Dix Avenue and Southfield Road. The 30-acre site was purchased from the city for $450,000. When it opened, the Sears store was the largest Sears in the world; it is still in operation. The once ubiquitous Cunningham Drug and S. S. Kresge dime stores are long gone.

Gus Pelton owned Lincoln Park Roofing and Sheet Metal at 1706 Victoria Avenue.

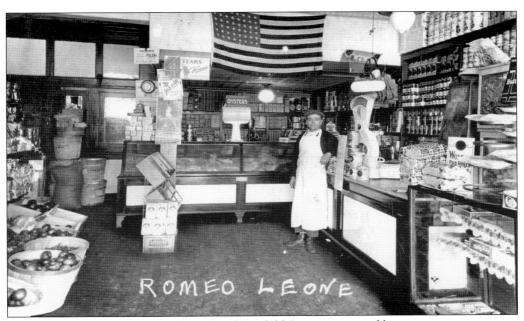

Leone's Market at Fort Park Boulevard and Garfield Street is pictured here.

This image of Toleikis Grocery is from the 1920s. Joseph Toleikis ran this grocery store at the Fort Street and Southfield Road corner.

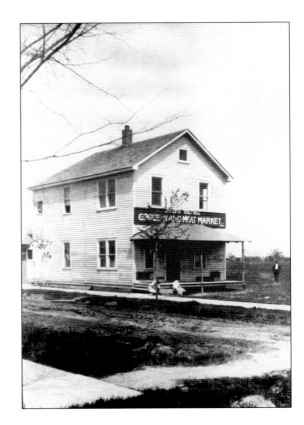

M. R. Levy, realtor, is pictured here. Chicago-born Maurice Levy became a real-estate agent for the St. Cosme Land Company, which developed early Lincoln Park subdivisions such as Elmwood Park. Levy worked downtown selling lots in the Ecorse Township area that was to become known as Lincoln Park. At the end of World War I, interest in the Fort Street and Southfield Road area grew. Thus, he opened a small "office" in an apple orchard owned by the Keppen family with only a card table for equipment. Apple orchards were plentiful, and many enjoyed the drive from Detroit to view the beautiful spring apple blossoms. In 1921, Levy opened his own real-estate office near the northwest corner of Fort Street and Southfield Road. When plans were announced in the late 1920s to widen Fort Street from a two-lane road to a 204-foot superhighway, Maurice Levy was one of the few Lincoln Parkers who approved of the project. Levy later branched out into construction, building the Park Theater as well as the first Lincoln Park library and the post office at Fort and Russell Streets.

The Old German Village is pictured here at 1526 Fort Street in the early 1930s. Due to Germany's involvement in World War II, city leaders asked that the name be changed. As a result, the tavern became Bud's Village. The bar featured hand-painted murals depicting scenes of old German village life. Pictured here is the amateur football team sponsored by the business. Games were played across the street in a field next to the Park Theater. On the left, the man in the hat is the team's manager and owner of the business, William "Bud" Humphrey. In 1947, the business moved to Fort and Gregory Streets and operated as the Pioneer's Inn.

Originally, Lincoln Park was served by rural-route deliveries from Dearborn and Wyandotte. But having grown from a population of several hundred at the time of Lincoln Park's village incorporation in 1921 to an even larger population in 1925, the city was finally large enough to support a branch post office. Including a postal superintendent and mailmen, the number of postal employees grew as the city grew. The first post office, a branch of the Detroit post office, was originally located in this rented building at 1471 Fort Street.

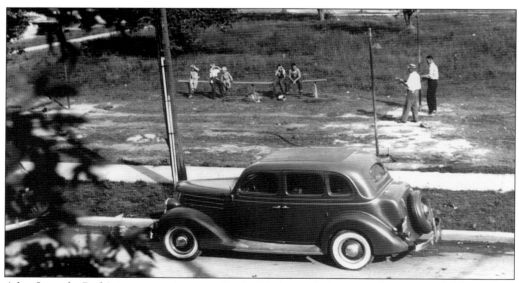

After Lincoln Park's incorporation as a city in 1925, population growth continued. Many plans of obtaining a new post office never materialized until 1937, when Mayor Jasper Howard named a committee to seek federal funds for the project. Committee members included Russell V. White, George Shanley, and R. H. Nass, as well as Pat Reid, Anthony Klopfer, and Francis Knap. Aided by city treasurer Floyd Harrison and Detroit postmaster Roscoe B. Huston, Congressman John Lesinski finally won congressional approval, and the land was purchased for $15,000. Originally at this corner was a hot-dog stand owned by Herman Quandt.

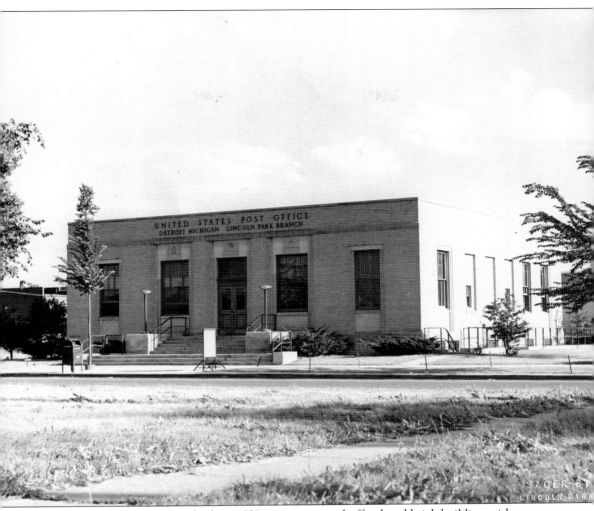

The Lincoln Park post office, built in 1939, is a one-story, buff-colored brick building with stone carvings over the front entrance and two front windows. The stone carvings represent three types of mail transportation: plane, train, and ship. The building was designed by the office of the supervising architect of the treasury, Louis A. Simon, and built by the Henry Dattner Company, general contractors of Detroit. This particular design was one used for many United States post offices in Michigan. James Kerley, a construction engineer with the Treasury Department, inspected each stage of work on the building and moved to Lincoln Park to be near the project. The final cost of the building, which was completed about the end of July 1939, was about $80,000. The building's lobby originally housed a mural, *Hauling in the Nets*, by Michigan artist Zoltan Sepeshy. The mural was removed at some point and now hangs in the Marine Museum on Beaver Island, Michigan.

At the August 5, 1939, dedication of the new Lincoln Park post office were Congressman John Lesinski and Detroit postmaster Roscoe B. Houston. Mayor Jasper N. Howard welcomed the crowd after the parade. The dedication chairman, city treasurer Floyd W. Harrison, then took over as master of ceremonies. Congressman Lesinski delivered the main address and Roscoe B. Houston presented the keys of the new post office to James V. Southers, Lincoln Park postal superintendent. A banquet followed. The Park Theater gave free tickets to important dignitaries.

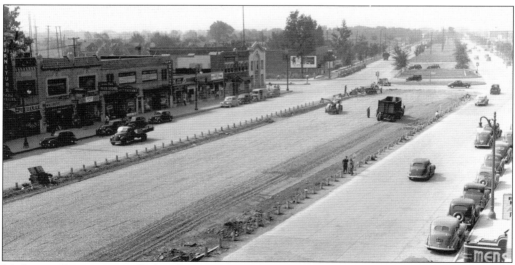

Median parking was installed in the 1930s on Fort Street between Southfield Road and Arlington Street. When the state assumed control of the median in the 1980s and removed the parking, many say it hurt local businesses.

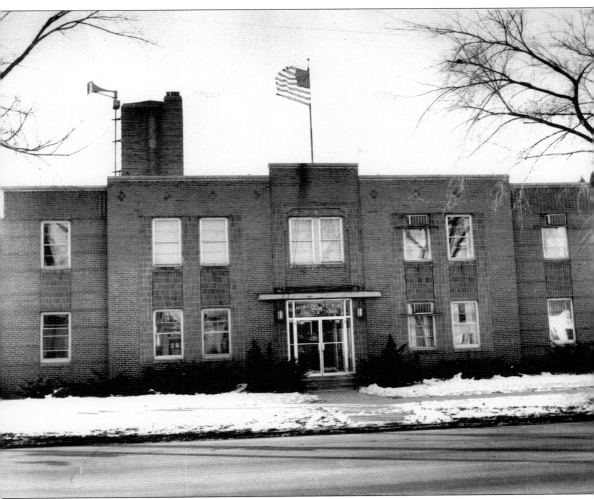

The Lincoln Park City Hall, built in 1935 for $80,000, was one of the largest Works Progress Administration projects in the Downriver area. At the site once sat Lincoln Park's department of public works, police, and fire buildings. Designed in a U shape, the new city hall featured space for all city departments, as well as police and fire departments. The art deco building has a 50-foot tower for drying fire hoses. Decorative brick work is featured around the windows at the cornice and as a series of string courses. For the 1936 dedication, a parade of civic, fraternal, military, and social organizations took place. The parade, led by the Lincoln Park High School band, started at Cicotte and Fort Streets. Mayor Jasper Howard accepted keys from the Works Projects Administration administrator. After the dedication, Fort Park Boulevard was turned into an outdoor ballroom.

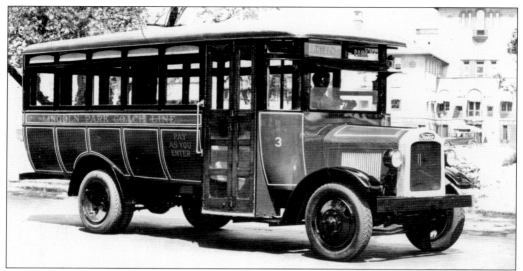

The Lincoln Park Coach Line began offering local bus service within Lincoln Park in 1925. By 1927, it was out of business but resumed service in 1929 as Lincoln Park Bus Company. Walter H. Staffe was the owner, providing service to Detroit and the Ford Rouge plant. At certain points, service to Detroit, Belle Isle (above), and other spots of entertainment was available. The coach pictured is a 25-passenger 1936–1937 Ford. The Depression eventually cut patronage to nearly zero. Thus, in 1933, Dearborn Coach Company acquired Lincoln Park Bus Company as a subsidiary.

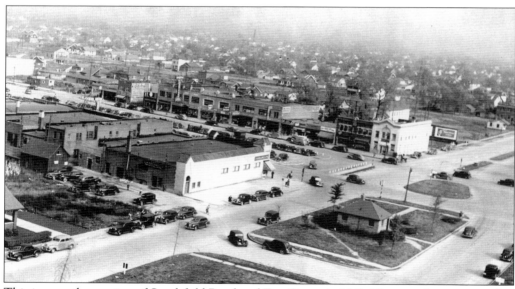

This is a northeast view of Southfield Road and Fort Street in 1941. This aerial image reveals a nearly developed downtown with a plenitude of residential homes in the background. The first 20 years of growth in this former farmland had been impressive by any measure. Starting from just a few hundred persons in 1920 and growing to 15,236 by 1940, few could have imagined how this would pale in comparison to the next 20 years. From the period of 1946 to 1955, 7,963 permits for new-home construction were issued, with 2,011 in 1949 alone. By 1960, the population would balloon to 53,933.

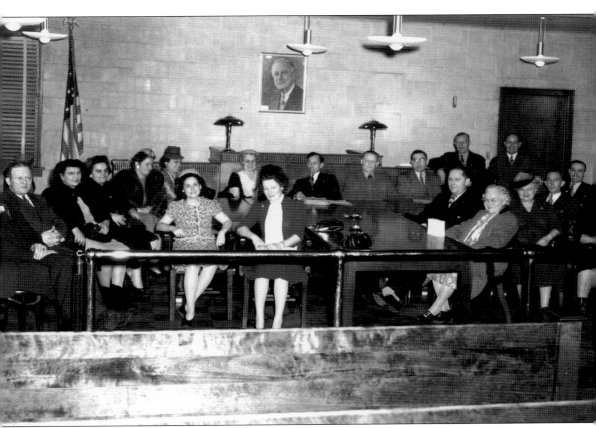

Members of the President's Ball Committee include Warren Webb, Norman Pugh, Adele Moore, Dorothy Nixon, Mrs. Howard, Mayor Jasper Howard, Russell V. White, George Barber, Floyd Harrison, Clarence Hicks, Mae V Smith, Chester Mozzena, and Walter Gibson. The President's Ball was an annual event coinciding with President Roosevelt's birthday. Its purpose was to raise funds for the National Foundation for Infantile Paralysis. Communities throughout the nation participated in this cause. Lincoln Park hosted a dance in 1940 in the Lincoln Park High School gymnasium, with more than 650 persons attending. Similar events were scheduled in Ecorse, Melvindale, and Allen Park.

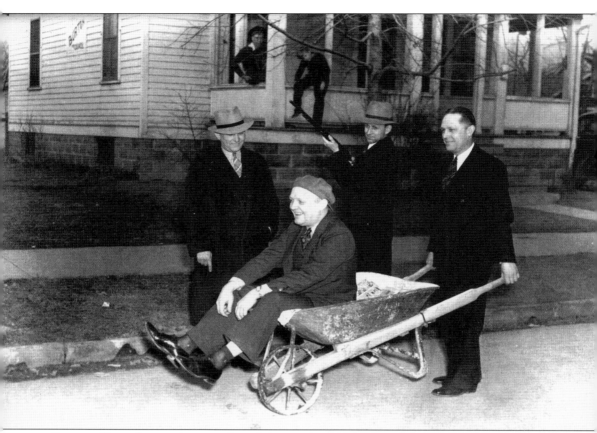

Paying off an election bet are, from left to right, councilman Clarence Hicks, councilman Russell White (in wheelbarrow), Mayor Jasper Howard (with gun), and councilman Frank Burton. Jasper N. Howard devoted 18 years to public service in Lincoln Park. He served on the city council from 1929 to 1935 and then as mayor until 1947. Working with the council, he paid off many of the city's early debts, including script notes used to pay city employees, past-due amounts due the City of Detroit for water, and Detroit Edison electric bills. During his tenure, he oversaw the building of Municipal Building and set up a postwar $1 million fund to finance additional infrastructure and park improvements in the city.

Mayor Stephan Creutz, Russell V. White, Clarence Hicks, Everette Winslow, Chet Mozzena, Frank Burton, and George Barber are shown walking in the 1950 Memorial Day parade. There is a rich history of Memorial Day parades in Lincoln Park. The first parade was staged in 1925, the year Lincoln Park became a city. From the early days through modern times, local politicians have participated in the parade in order to be seen by the voting public.

The Memorial Day parade of 1951 is pictured here, with Gov. G. Mennen "Soapy" Williams. By the early 1950s, Lincoln Park was the third-largest city in Wayne County, behind Detroit and Dearborn, and was a regular stop for politicians visiting the area. The governor's name Soapy came from his grandfather's business, which produced the men's-care brand *Mennen*. Known for his colorful bow ties and energetic personality, it was said he could say "hello" in 17 languages, a valuable trait when visiting a melting pot like Lincoln Park.

Lincoln Park's original traffic safety bureau is pictured here and includes patrolman Alexander Biro, Corp. Robert Hook, Sgt. Edwin Wild, patrolman Ira Propes, patrolman Steve Gasper, and Chief Floyd Crichton. Also shown is the safety car nicknamed "White Fang," a reference to a puppet character in a hugely popular, locally produced 1950s television show, *Lunch with Soupy*, starring Soupy Sales. White Fang and Black Tooth were known on the show respectively as, "the meanest and sweetest dogs in all of Deeeeetroit" . . . and Lincoln Park, too, for that matter!

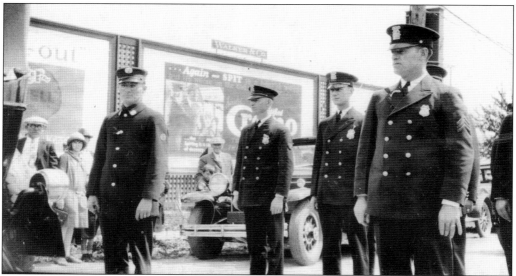

Pictured in a 1932 parade that included the Lincoln Park police and fire departments are Orie Hand, Floyd Davis, William Vest, and William Walton. Orie Hand joined the fire department when it was organized as a full-time unit on April 22, 1925. He was present when the new department made its first run on April 27, 1925, at 5:40 p.m. to the Ryan Foundry in Ecorse, Michigan. Hand later became fire chief and served in that capacity from 1944 until 1950.

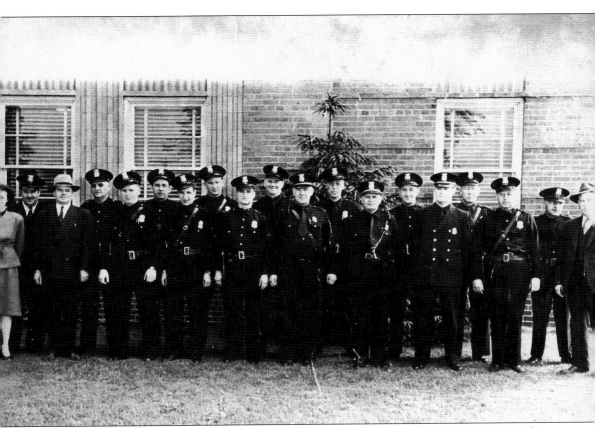

Pictured here is the 1946 Lincoln Park police department under Chief Robert Duncan Sr., who served as an officer from July 16, 1946, to September 1, 1978. Pictured from left to right are Em Daley (patrolwoman/matron, 1942–1948), Ernest Dales, (patrolman/dog warden, 1945–1947), Floyd Crichton (motorcycle officer, 1925–1936; chief, 1936–1960), Luther Dixon (sergeant, 1927–1952), Harold Heim (patrolman/sergeant, 1944–1956), Charles Hood (patrolman/deputy chief, 1936–1961), Harold Smith (patrolman/radio operator, 1941–1949), Homer Eugene Gullion (patrolman/detective sergeant, 1945–1970), Carl Walkmaster (patrolman/chief, 1942–1967), Allen Cummings (patrolman/motorcycle officer/lieutenant, 1939–1969), Henry Krueger (lieutenant, 1926–1951), Perry Heath (patrolman/deputy chief, 1935–1967), Roscoe Ball (lieutenant, 1924–1950), Paul Neuman (patrolman/motorcycle officer, 1927–1952), William Walton (lieutenant, 1926–1952), Walter Early (patrol officer/dog warden/sergeant, 1936–1966), Glenn Tuttle (patrolman/lieutenant, 1928–1953), Oswald "Buck" Porter (patrolman killed in the line of duty, 1927–1948), and Charles Barker (detective lieutenant, 1926–1951; chief of police 1931–1936).

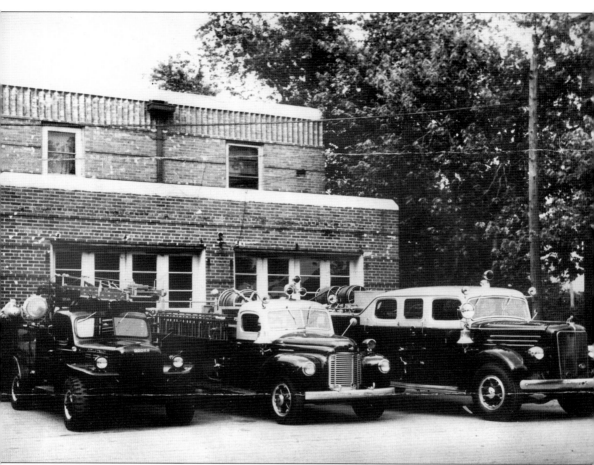

The Lincoln Park fire department came into existence on June 5, 1922, when the newly formed village appropriated $1,478.50 to fund its creation. Initially the fire department shared quarters with the police department. In 1927, the departments were separated, with the fire department occupying space at the corner of Southfield Road and Fort Park Boulevard. In 1929, the fire department occupied the rear section of the city hall building. Here municipal vehicles are parked outside the city hall, built in 1935. This picture, dating to the early 1950s, shows the department's firefighting apparatus. It was a very impressive fleet for the times.

The Lincoln Park police department has come a long way since its humble beginnings on July 4, 1921, when it hired its first officer, Joseph Rowe. On June 12, 1955, the police department dedicated its new, state-of-the-art $200,000 police headquarters. Funding came from proceeds of the $450,000 land sale to Sears, Roebuck and Company. Considered a model for its time, this facility was constructed under the leadership of Chief Floyd M. Crichton. Crichton joined the force in 1925 and became chief in 1936. He held that post until 1960, making him Lincoln Park's longest-serving police chief.

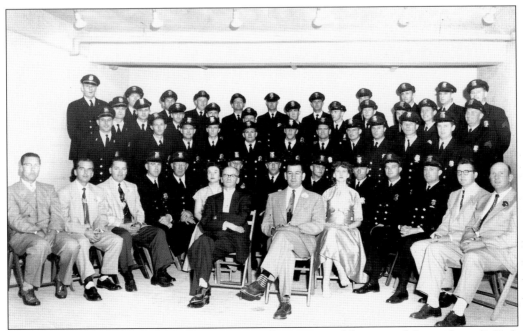

This is the Lincoln Park police department after the opening of the state-of-the-art Lincoln Park police department building.

During the 1950s, Lincoln Parkers often traveled in a Lincoln Park Coach Company bus. Tokens minted with the words "Lincoln Park Public Transportation" were used as fare.

This image shows Park and Washington in the spring—well, they call it Downriver for a reason, too, you know! While some communities categorized extreme water saturation events as 10-year or 100-year flood events, Downriver residents think of them more as "spring or summer."

This is Jack Taylor's baseball team. Baseball fever was spreading through the country in the 1930s and 1940s, and Lincoln Park was no exception. Teams consisting of local talent were sponsored by area businesses and organizations, including the Lincoln Park police, and provided a source of recreation and entertainment to area residents. In the 1950s, teams such as the Businessmen and the Junior Blue Jackets would find themselves competing for the Lincoln Park Senior Baseball League championship.

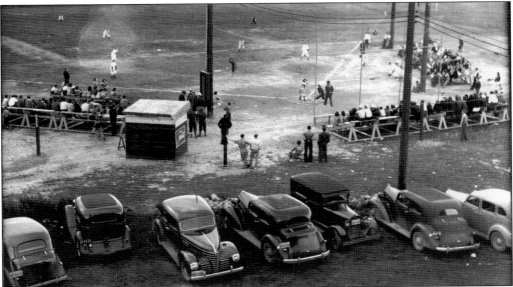

Quandt Park is located on Southfield Road and Dix Street. Frank Kuzminski brought Little League baseball to Lincoln Park in 1953, a first for Downriver. The league consisted of two divisions, eight teams, and 120 kids. Games were played on land donated by the Lincoln Park School Board. A contest was held to name the site, and it became Jack Shannon Field, after a Lafayette schoolteacher and coach who died the prior year at age 25 from polio. By the early 1960s, the league had expanded to three divisions, 52 teams, and 780 kids. Quandt Park is now the home for Little League North.

The Lincoln Park Department of Public Services (DPS) had humble beginnings with three men and a Model T truck in October 1962. The DPS grew to 53 full-time employees and 40 temporary laborers. The DPS building houses the offices, machinery, and equipment of the DPS department. It was built for $500,000.

The Band Shell is another recreational facility located in Lincoln Park. The center is home to recreational activities for youths as well as seniors, as it is also known as the Senior Center as well as the Kennedy Memorial Building. Originally known as Civic Building and Band Shell, it was constructed for $63,000 in 1954. Lincoln Park organizations raised a portion of the construction costs.

Pictured at the 1964 Kennedy Memorial Building dedication are, from left to right, Bob De Mars, Alex Antonishak, Dan Brown, and Charles Nixon. Bob De Mars would eventually become mayor of Lincoln Park. Alex Antonishak was on the Historical Commission. Dan Brown was parks and recreation director. Charles Nixon owned Nixon Funeral Home. After the death of Pres. John F. Kennedy, the City of Lincoln Park renamed the Civic Building and Band Shell as the John F. Kennedy Memorial Building.

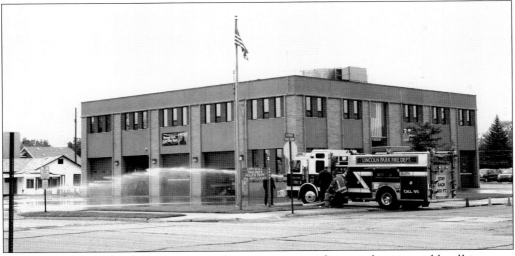

The Lincoln Park fire department was for many years without a place it could call its own. When it was organized in April 1925, it shared quarters with the police department. For many years afterward, it operated out of the back of the city hall building at Southfield Road and Fort Park Boulevard. Finally, in 1963, after receiving a federal grant of $116,000, this new $232,000, two-story, 13,500-square-foot facility was constructed on the southwest corner of Fort Park Boulevard and Cleophus Street.

The Lincoln Park Community Center was built in 1972 and is most known for its ice, used for hockey and figure skating. The community center has 38,311 square feet of recreation space, including an Olympic-size pool, locker rooms, offices, restrooms, and a 85-by-200-foot regulation ice rink. The center also boasts a pool with a slide for families to enjoy. The municipal pool was the first phase of construction that was completed on June 24, 1972. Construction of the ice rink began on June 23, 1973.

This is Lincoln Park, at the Southfield Road and Fort Street intersection. This intersection marks the heart of the downtown area. This area experienced its beginnings when the Lincoln Park Approvement Association met to make plans for incorporation as a village. They called a group of settlers together at the Strowig School, and in 1921, their community became a village. In 1925, Lincoln Park became a city.

Ten

CHURCHES AND
ORGANIZATIONS

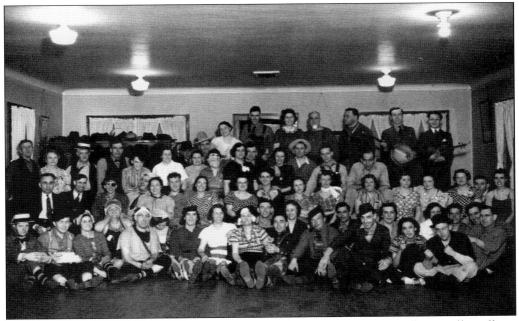

The Lincoln Park Exchange Club was organized in 1924 when Lincoln Park was still a village. Floyd Harrison was the charter president. The Lincoln Park Exchange Club was one of the few service clubs in the country that at one time had its own building. The building was known as the Exchange Club Bungalow and was built in 1927 on Victoria Street near Southfield Road. It was a regular meeting place for some local organizations until its 1963 demolition for urban renewal projects. Pictured here are Exchange Club members at one of their many functions at the Bungalow.

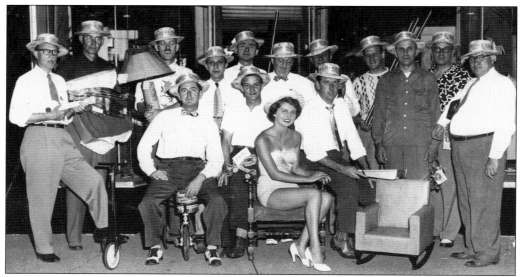

Nancy Doyle, the Lincoln Park Day Club Queen for the Lincoln Park silver anniversary celebration, gets a preview of some of the $2,000 in prizes to be awarded to the winners during the Lincoln Park Day at Bob-Lo Island. Pictured behind the queen are, from left to right, the following: (seated) Dr. Robert Conlogue, Jack Johns, and Wilford Moning; (standing) are Morrie Sager, Lawrence Bailey, James Dunn, James Osborne, Robert Avis, Charles Nixon, Clarence Hicks, Alex Petri, James Kier, Donald Evans, and Jim Charnock. The members are wearing special "Lincoln Park Day" hats, which had been revived from the early Bob-Lo days.

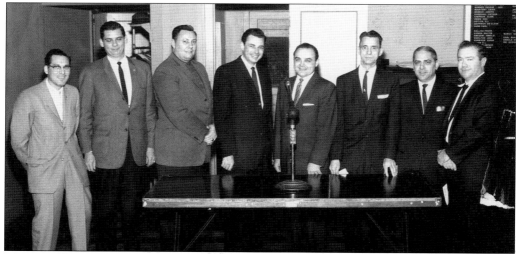

The Lincoln Park Jaycees pictured here are, from left to right, William Morrison, Joseph Knowles, Richard Richardson, Dick Meyerson (Jaycee state president), Ron Stempien, Nick Raar, Vic Tenaglia, and Mike Kurvial. Ann Raar organized the Lincoln Park Junior Chamber of Commerce Auxiliary in 1944, which later became the Lincoln Park Jaycee Auxiliary. The Jaycees' parent organization originally formed in 1915 as an organization for and by young men between the ages of 21 and 35 in St. Louis, Missouri. In 1946, Lincoln Park's Jaycees celebrated the silver anniversary of Lincoln Park with a jubilee queen, old-timers' dinner, parade, sidewalk festivities, and a picnic.

The Lincoln Park Rotary Club was sponsored by the Wyandotte Rotary Club and chartered on May 13, 1949. Willard Tressler, a realtor, was the first president. The club started with 18 members. The Lincoln Park Rotary Club is part of an international service organization that bases its membership on a cross section of the community. Each member is a representative of their own business and profession. In the early days of the Lincoln Park chapter, its members were very active with Easter Seals. For many years, popular Rotary Club fund-raisers were Christmas tree sales and pancake breakfasts.

Lincoln Park Rotary Club member Ivan R. McFaul assists Michigan supreme court justice John B. Swainson, honorary chairman for the 1973 Easter Seals campaign, in presenting Jane Devereaux, executive director for the Wayne County Easter Seals program, a citation for her outstanding service to the Easter Seals. Ivan McFaul, at one point, had served as president of the Easter Seals organization for Wayne County. Lincoln Park Rotary Club participation with the Easter Seals was not limited to fund-raising. They also had installed a new roof on the Easter Seals building.

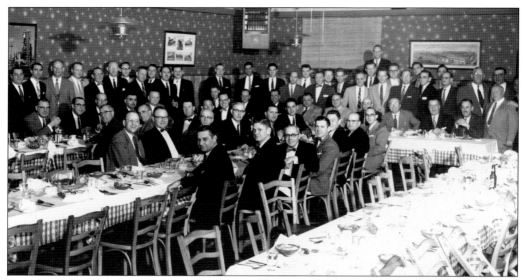

Lincoln Park Chamber of Commerce originally started as the Lincoln Park Businessmen's Association in 1947 in the basement of the Lucas Restaurant. With 32 charter members, the association organized and elected the following charter officers: Jack Johns (president), Mac Fisher (vice president), Nathan Minkin (secretary), and Rudolph Virta (treasurer). The board of directors was Joseph Blumrosen, Louis Eder, Joseph Renier, Edwin Baustert, Clinton Knoch, Dennis Hickey, and William S. Mellus. Its purpose was to make Lincoln Park the leading shopping center in the Downriver area. From 1947 to 1951, the organization worked hard to improve shopping conditions in Lincoln Park.

The Lincoln Park Businessmen's Association merged into the new Lincoln Park Chamber of Commerce in 1951 with objectives such as off-street parking, sidewalk meter surveys, business area cleanups, a sponsored community center, solicitation controls, and holiday projects and promotions. Officers were Rudolph Virta (president), Wilfred Moning (vice president), James Dunn (secretary), and Joseph Blumrosen (treasurer). Directors were Edwin Baustert, Robert Borgondy, William Deshaw, Mac Fisher, Jack Johns, Thomas Knowles, and William S. Mellus. Pictured here on April 30, 1986, are members Bill Suzore, Judge William Chapman, Dan Lobb, Frank Chiarelli, John Solosy, Vincine Bruzos, Ken Mixter, Dick Busen, and Vern Stough.

The Lincoln Park Woman's Club Garden Division is pictured in 1940 at Ruth Blumrosen's home. They are making sandwiches while planning a card party for their building fund. Pictured here are Lovey North, Hazel Foote, Frances Gahan, Ruth Blumrosen, Lois Syfert, and Muriel Healy. The club was organized in 1932 to promote the spirit of cooperation for the purpose of culture and civic improvement. Some members were already in a literary guild, but as interest grew into adopting more projects, this club formed. They held their first luncheon on May 19, 1933, at the Grosse Ile Golf and Country Club.

Lincoln Park Woman's Club beautified things by gardening. They designed a flower garden at the intersection of Fort Street and Southfield Road. During World War II, the club was active in the war effort. They prepared sandwiches and baked cakes for the local United Service organizations as well as sold war bonds. Donations were made to the American Red Cross and the War Chest. They received a 1942 citation from the United States Treasury Department for their work on behalf of the War Financing Program. Pictured here are, from left to right, Mrs. Paul Gates, unidentified, Esther Kutt, Francis Gahan, and Lois Beauthein.

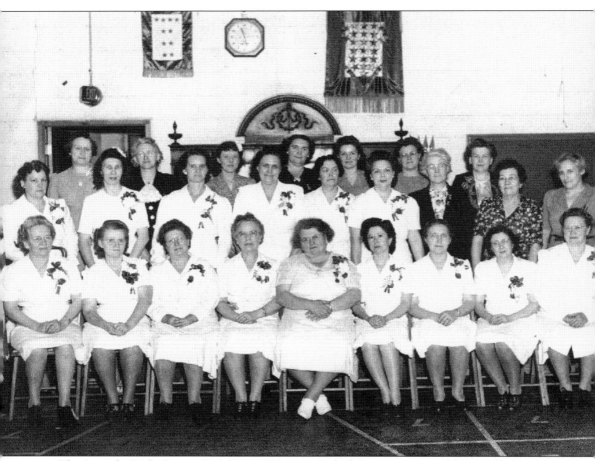

The Lincoln Park George L. Morgan Woman's Relief Corps is pictured here. All the women in white are the charter members. The George L. Morgan corps was established on March 26, 1945, by 37 charter members under the leadership of Ethel Ferguson, who had originally been a member of a unit in Detroit. The chapter took the name of George L. Morgan, who was one of two remaining Civil War veterans at the time. The Woman's Relief Corps was founded in 1864 as an organization of Civil War nurses who worked on the battlefields. In 1883, it became an auxiliary to the Grand Army of the Republic, a patriotic association of soldiers of that war. The purpose of the corps is to perpetuate the memory of the Grand Army; encourage loyalty, patriotism, and love of country; and to assist veterans. The corps donated electric razors and funds to the Allen Park Veterans Hospital.

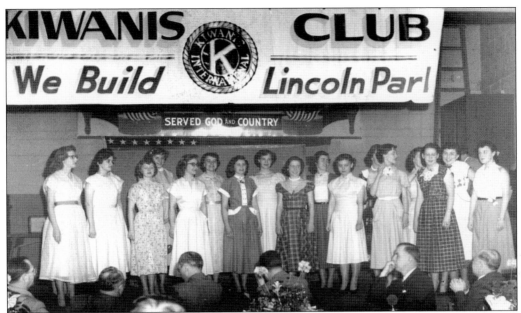

The Lincoln Park Kiwanis Club was organized on November 17, 1944. They organized boys' baseball, bowling leagues, and summer camp. They also furnished transportation for school children to concerts and financed optical care for underprivileged city children. Initially, they met each Wednesday at the Lincoln Park Odd Fellow Hall at Victoria and O'Connor Streets. Charter officers of the group were Walter E. Gibson (president), Dr. Owen A. Kean (vice president), and Arnold W. Isler (secretary and treasurer). Charter directors were Clarence E. Colwell, Ernest North, John Hancock, Dr. Thomas Jamieson, Walter Logan, Wade Bogard, and Arthur P. Zirkaloso.

First Baptist Church began building this three-story, Colonial-style church in 1947. Due to World War II labor problems and material shortages, construction was halted. Services were held in the basement since all that was completed and covered was a temporary roof. The sanctuary was completed in 1952. Prior to building this church, First Baptist Church had owned the former First Methodist Church from 1925 to 1952. In the early 1920s, they rented an unfinished tar-papered building at Cicotte and Fort Streets. First Baptist Church was established in 1925, gathering for "cottage prayer meetings" during the week in each others' homes.

Hungarian Baptist Church, pictured here, was originally home to Calvary Lutheran Church. The church at Cicotte and Chandler Streets was completed and dedicated on December 14, 1936, by the congregation of Calvary Lutheran Church. The latter congregation moved out of this church in 1957 when their new church at Electric and Pagel Streets was completed. In 1956, St. George Greek Orthodox Church purchased the church after their Porter Street church was destroyed by a tornado. St. George Greek Orthodox Church remained there until the mid-1970s when their Southgate church was built. First Hungarian Baptist Church purchased the church in the late 1970s.

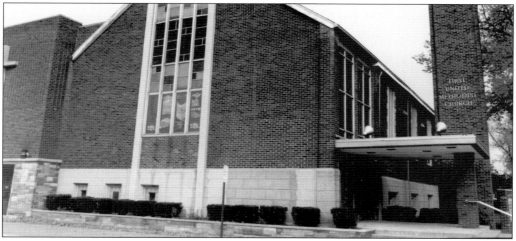

First United Methodist Church was built in 1925 by the former congregation of First Methodist Church. The site at Fort Park Boulevard and Anne Street was purchased the year before for $4,600. After selling the original church on Victoria Street to First Baptist Church, services were held in the Raupp School until the new building was complete. The church basement and adjoining parsonage was completed in 1925. A large church bell was presented to the church in 1925 by a group of Detroit real-estate men. Over the years, the church construction was completed in stages due to financial conditions.

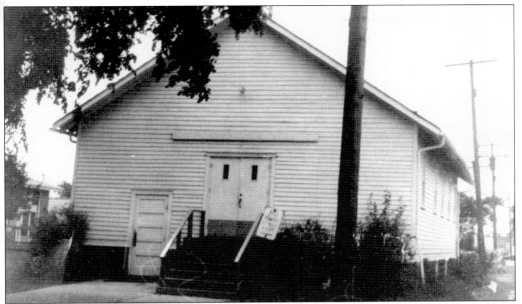

First Methodist Church was founded in the fall of 1920, when the first religious services were held. Rev. L. F. Rayfield of Methodist Home Missions offered his services. In early 1921, Reverend Rayfield gathered area Methodists and others interested in the Methodist faith. A total of $800 was given by Methodist Home Missions and land was purchased. Donations from local residents and Fort Street Methodist Church of Detroit helped fund the building of the church. Reverend Rayfield became the pastor. Services were held until 1924, when a permanent church was built on Fort Park. The building was later sold to First Baptist Church.

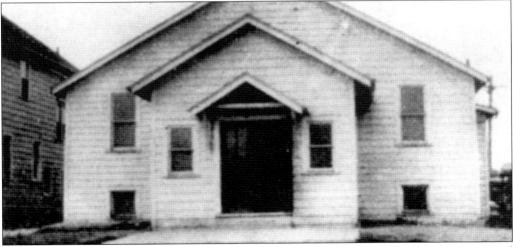

St. Henry's Catholic Church was founded in 1923 with 25 families. The church was named after St. Henry of Bavaria, a prominent 14th-century churchman, and also in recognition of the close proximity to Henry Ford's properties along the Rouge River. Rev. Vincent J. Toole was the first pastor of St. Henry's. By 1924, church membership exceeded 300 families, and a temporary two-story church was built. The first floor consisted of a parish hall, bowling alley, and kitchen. The second floor seated 800 people. In 1928, a large, brick Gothic-style church was built. A new contemporary church replaced it in 1964.

INDEX

Blumrosen's Economy Store 85
Bondie family 14, 18–20, 74
Chiarelli and Leone's Market 64
Chiarelli's Market 61
Chief Pontiac 10
Clemente's Bar and Restaurant 61, 63–64
Clinton Knoch Florist 87
Drouillard family 19–21
Eastern Europeans (Hungarians and Slovaks)
 66–67
Ecorse Township 14–15
Ecorse Township district No. 10 72–73
Ecorse Township district No. 5 72
Ecorse Township School Board 27, 77
Flowers by Ed Lobb 87
Ford Motor Company 43, 45, 47, 50, 58
Goodell family 14, 22, 25–27, 33–34, 54, 73
Goodell School 27, 54, 73–75, 78–79
Greeks 66–67
Green family 23, 30
Harrison, Floyd 53, 86, 102, 104, 107, 119
Italians 23, 30
Johnston's Store 91
Karol Grocery Store 94
Keppen family 21–24, 31, 54, 78
LeBlanc family 14–18, 31, 50, 78
LeBlanc Saloon 17
Lincoln Park Businessmen's Association 122
Lincoln Park City Hall and council chambers
 43, 52, 105
Lincoln Park Exchange Club 119–120
Lincoln Park Fire Department 110, 112, 117
Lincoln Park High School 77, 82–83, 105
Lincoln Park Historical Society and Museum
 21, 49, 75
Lincoln Park Police Department 55–56, 58,
 105, 110–111, 113
Lincoln Park Public Schools 54, 72–84
Lincoln Park School Board 27
Lincoln Park Sweet Shoppe 93
Lincoln Park Women's Club 85, 123
Lindeman family 21
Mellus Newspapers 94
Mexicans 72
Montie family 14–15, 21, 44
Old German Village 101
Park Theater 96, 104
Pioneer's Inn 90
post office 102–104
Quandt family 17, 31–36, 50, 52, 102
Quandt's Corners 32, 43, 50
Raupp family 27, 53, 75, 77
Renier Company 91
Rumsley family 28–29
Sabadash and Sabadash 39–40
Sabadash family 39–40
Sager Photographic Studio 92
St. Cosme, Pierre 12
Sally Sheer Shop 95
State Savings Bank of Lincoln Park 93
Strowig School 72
Toleikis Grocery 99
transportation 39, 42, 48–49, 105–106, 114
West Side Inn (Quandt's Saloon) 32, 34, 43
Woolworth's 88–89